The Soul of Vermont

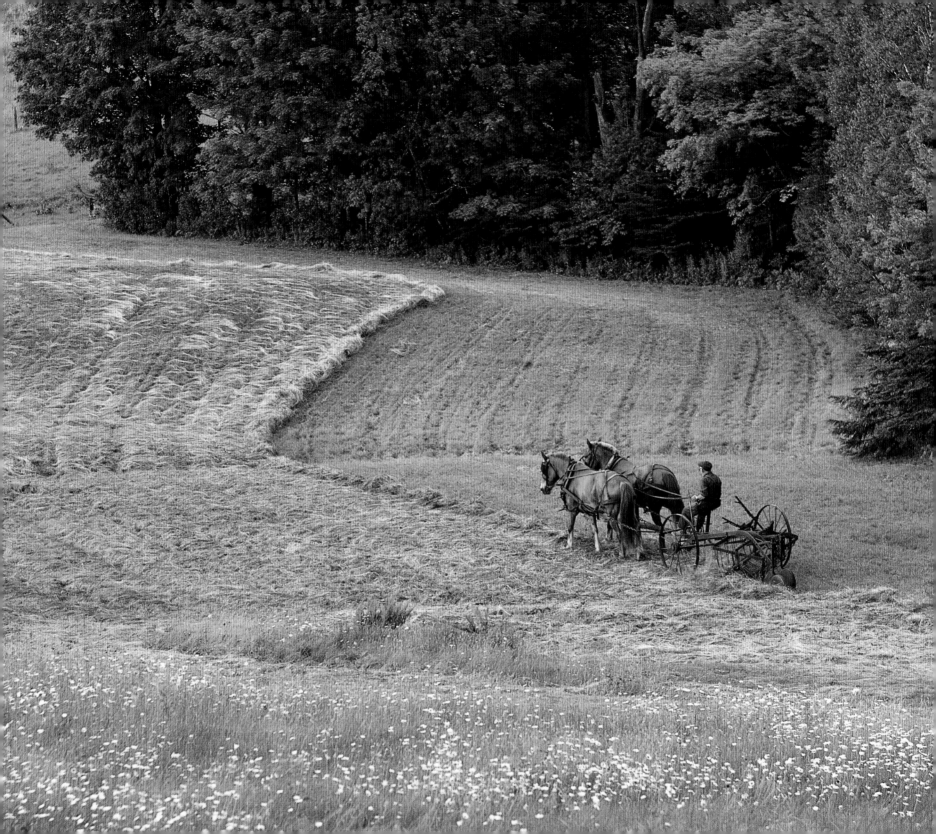

The Soul of Vermont

RICHARD W. BROWN

THE COUNTRYMAN PRESS
WOODSTOCK, VERMONT

Library of Congress Cataloging-in-Publication Data

Brown, Richard, 1945–
 The soul of Vermont / Richard W. Brown.--1st ed.
 p. cm.
 ISBN 0-88150-467-x
 1. Vermont--Pictorial works. 1. Title.
 F50 .B75 2001
 974.3--dc21 2001028053

Cover and interior design by Susan McClellan

Published by The Countryman Press
P.O. Box 748, Woodstock, Vermont 05091

Distributed by W. W. Norton & Company, Inc.
500 Fifth Avenue, New York, NY 10110

Printed in Italy by Mondadori Printing

10 9 8 7 6 5 4 3 2 1

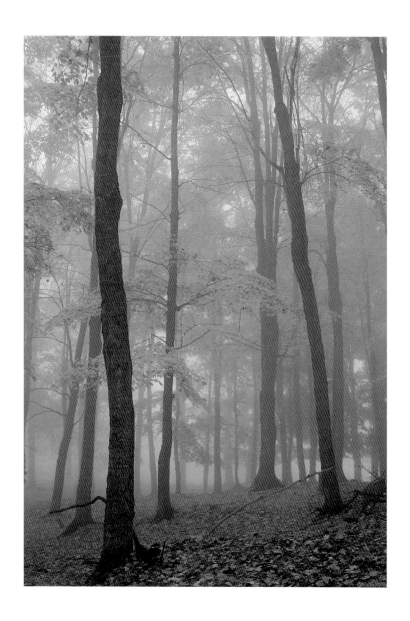

Contents

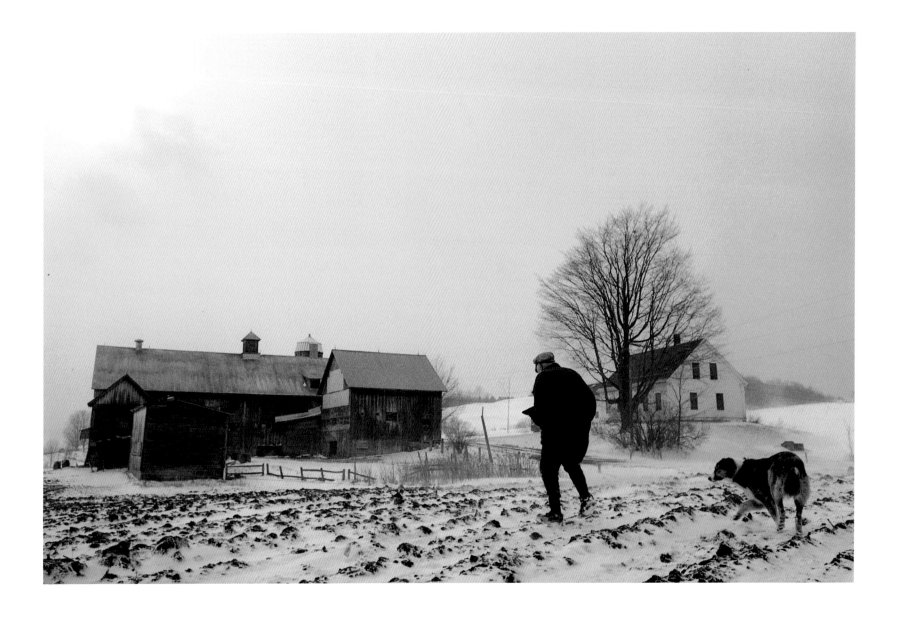

INTRODUCTION

I HAVE BEEN PHOTOGRAPHING VERMONT FOR OVER THIRTY years, searching for what, to my eye, gives this state its unique character. When I first moved to the small southern Vermont village of Whitingham in the late sixties to teach school and—what I hoped would become my true calling—take photographs, I was inspired by what was still wild in the Vermont landscape. In those youthful days, whenever I had the chance, I would head out before dawn, without even thinking of coffee, anxious to catch the first light. The excitement of discovery was my caffeine. A rhythmical patch of hay-scented ferns or a ghostly stand of birches would keep me thoroughly engrossed until the light grew too harsh or the lure of the local diner too enticing. In October, when my classroom glowed with a particularly seductive light reflected from the maples outside the window, I was as restless and frustrated as my most recalcitrant student.

After becoming a full-time photographer and moving to a dilapidated hill farm in Vermont's legendary Northeast Kingdom my focus began to change, or at least widen. I was still drawn to

nature, but it was Vermont's cultivated landscape, the harmonious pattern of field and forest, of pasture, tilled land, fencerow, and woodlot that I found most inspiring.

I grew up on the outskirts of Boston and all the fathers in my neighborhood (mothers did not work outside of the home in the fifties) took the train into the city and disappeared into offices for the day. There they no doubt did worthwhile things, but whatever they did was invisible. Their work bore little relation to their surroundings. The seasons were barely noticed, the weather was mostly an inconvenience, and their work had nothing to do with the small piece of land that they lived on other than to pay for the mortgage and property tax.

In Vermont I found the opposite was more often true. Farmers still managed to wrest a living from the obstinate weatherworn hills that were first cleared two centuries before. Loggers worked in the woods felling second-growth timber amidst the acrid smell of chain-saw exhaust and the incense of balsam and pine and spruce. In this rural backwater there was still an obvious connection between the people and the land.

THE MAJORITY OF THESE IMAGES HAVE NOT BEEN PUBLISHED before. Most were taken in the last few years, but there are a scat-tering from my entire career. The photographs cover all corners of the state but an admitted preponderance of them were taken in the Northeast Kingdom. There is always a home advantage in finding photographs in your immediate surroundings. Fewer opportunities are missed when they happen at your doorstep. And familiarity with one's own backyard does not, at least in my case, breed contempt, but on the contrary a deeper appreciation for the varying nuances of light, the subtleties of seasonal change, and the ongoing drama of the weather—especially bad weather: thunderstorms, snow-storms, and above all, fog.

Obviously I am drawn to certain subjects and themes. I have a weakness for birch trees, barns, draft horses, cemeteries, landscapes with sheep or cows in them, bodies of water, still or moving, the moon, rising or setting, and anything old or decrepit that bears witness to past Vermonters' short time in this obstinate paradise and their efforts to wrest a hard-won living from it. It is in the last pastoral remnants of Vermont's landscape and in the day-to-day lives of the people who continue to nurture this hardscrabble, begrudging Eden that the true soul of Vermont can be found.

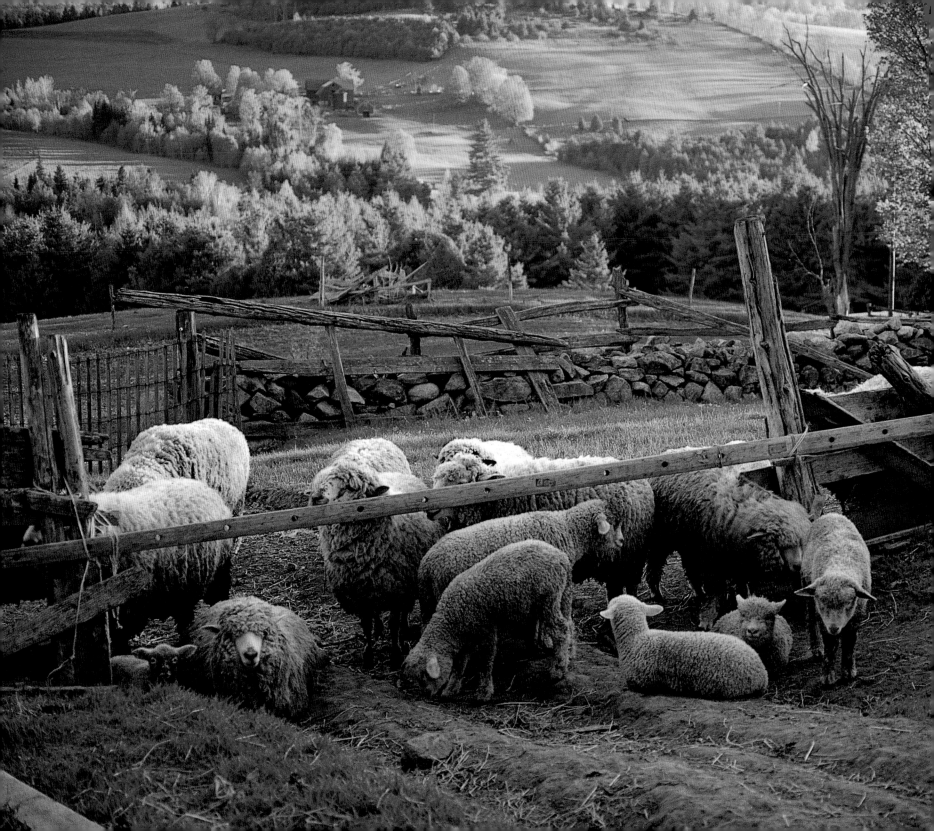

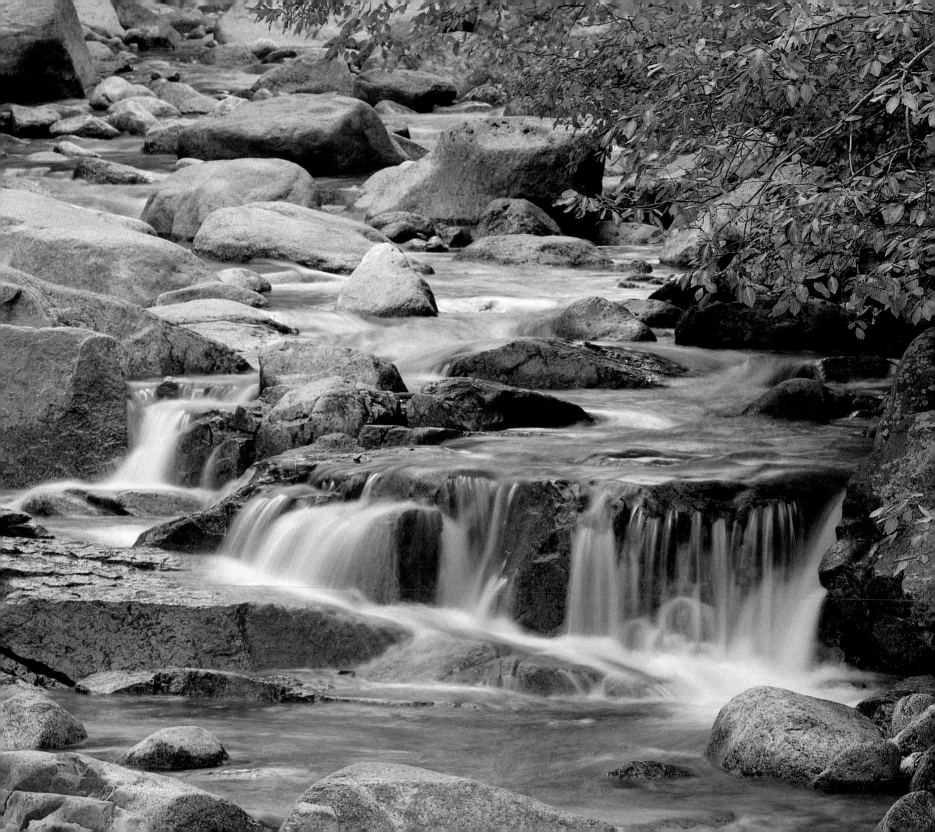

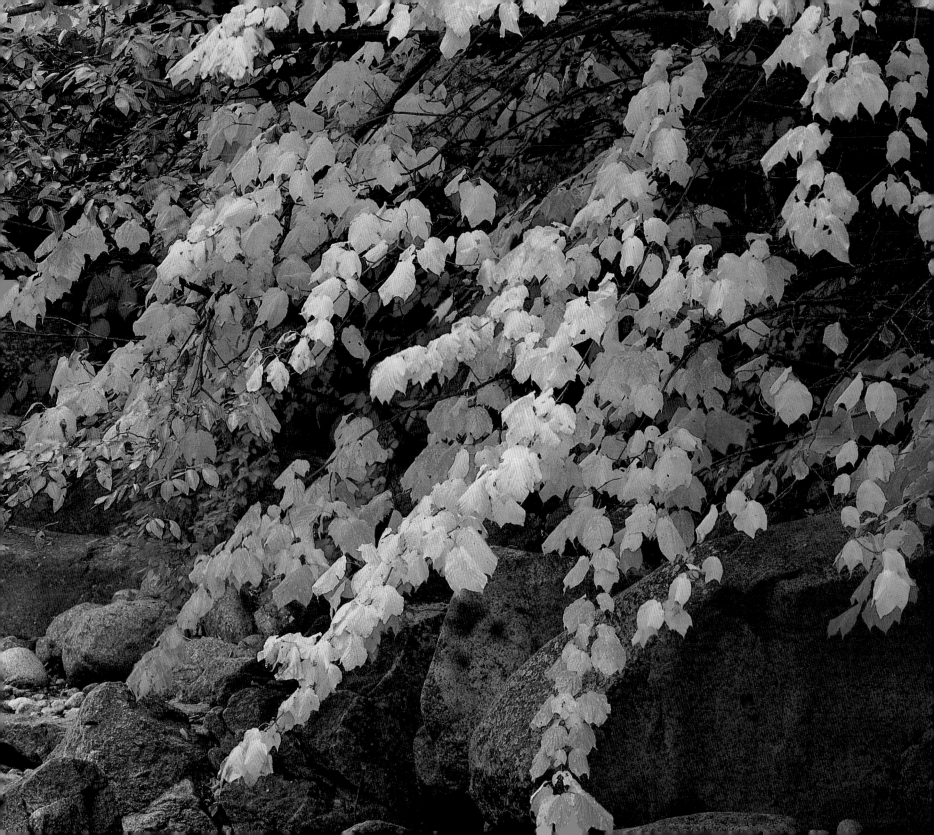

The OFF-SEASON

VERMONT'S BRIEFEST SEASON IS ALSO ITS MOST BASIC. THERE are no frills. It is that no-nonsense time of the year when the days are short, the trees are bare, and the wind has a knife edge. It is Vermont at its simplest and most fundamental—and, in rare moments, its most beautiful.

It is the pause that follows the falling leaves' unseemly display, the pause before the all-blanketing snows of winter—the off-season. It is nature catching her breath, granting a short reprieve. In a typical year it runs from the tail end of October until Thanksgiving. The tamaracks turn yellow-orange, the ground freezes rock hard, and the last great waves of geese pass overhead. We place fire-eyed pumpkins on our front steps and draw close to our woodstoves and fireplaces.

This urge to seek out warmth and light within our homes is no doubt a reaction to the ever earlier nightfall darkening our windows. Overstuffed chairs, good books, hot cocoa, and comatose house cats were all invented to be enjoyed during this season.

As October gives way to November the sun grows increasing shy

and lethargic. It seems to rise at the same hour as an average thirteen-year-old on a Saturday morning. Afternoons darken before they have barely begun. Even at noon, shadows are long and deep. Breaking from behind a cloud bank, the sun's brief appearance is now cause for wonderment, instantly transforming the dour landscape with its golden light, burnishing, sanctifying. Corn stubble and weed stalks gleam with miraculous solar alchemy.

But these moments of glory cannot fully alleviate the vague feelings of anxiety that always accompany this time of year. Who wouldn't feel concerned as things get inexorably colder and darker? We all feel some compunction to make ready for the coming hibernation. The Little Red Hens among us busy themselves with age-old rituals of preparation: the tar-paper skirt is fitted around the foundation; the chimney is cleaned; cordwood is stacked in neatly crafted rows in the woodshed; the snow tires are actually put on before it snows. But most of us procrastinate, lulled by a few false days of Indian summer, playing a game of chicken with the elements until we're forced to make do with stuffing bits of insulation into the draftiest corners of the cellar, or we're made to suffer the public ignominy of getting hauled out of a ditch by the town plow during the first real snowstorm.

Nature also seems to be preparing—tidying things up a bit before they are put to bed for the winter. The woods are swept bare, revealing the skin of the landscape, stretched thin over the bony ridge of a mountain flank, or lying in thick folds along the sensuous curve of a river valley. Stone walls reemerge from the growing season's tangle of milkweed and goldenrod, their ubiquity always a wonder. The air is insect-free, clear and clean-smelling.

It is an acquired taste, this spare season. Tourists are non-existent at this time of year. Vermonters often have ambivalent feelings about it. Hunters are, of course, making merry in their deer camps. But it is as a hunter of special moments with a camera that I have come to love it. No other season brings the visual surprises of a Vermont stripped to its core. And no other season, I believe, comes closer to matching the down-to-earth, Yankee character of its inhabitants.

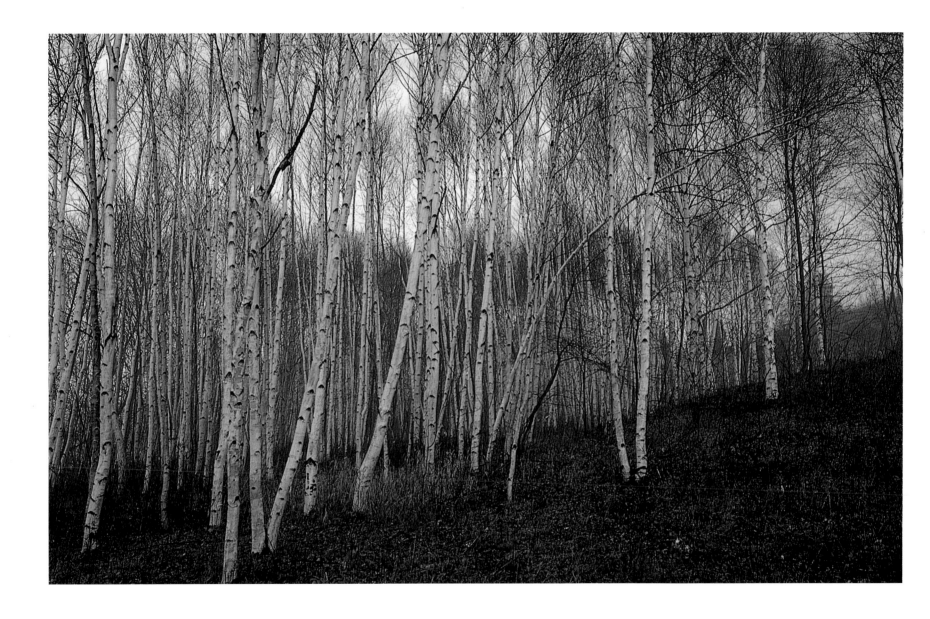

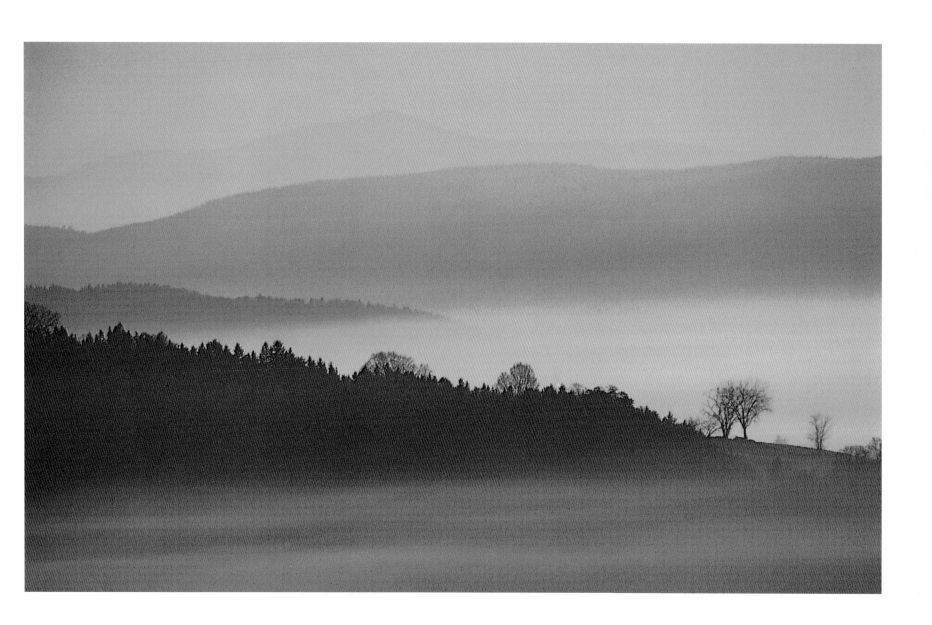

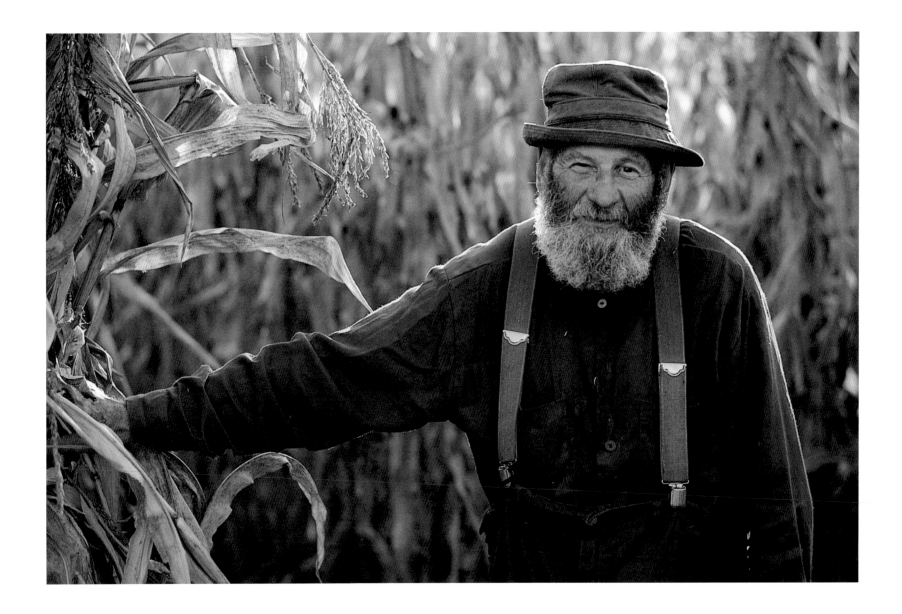

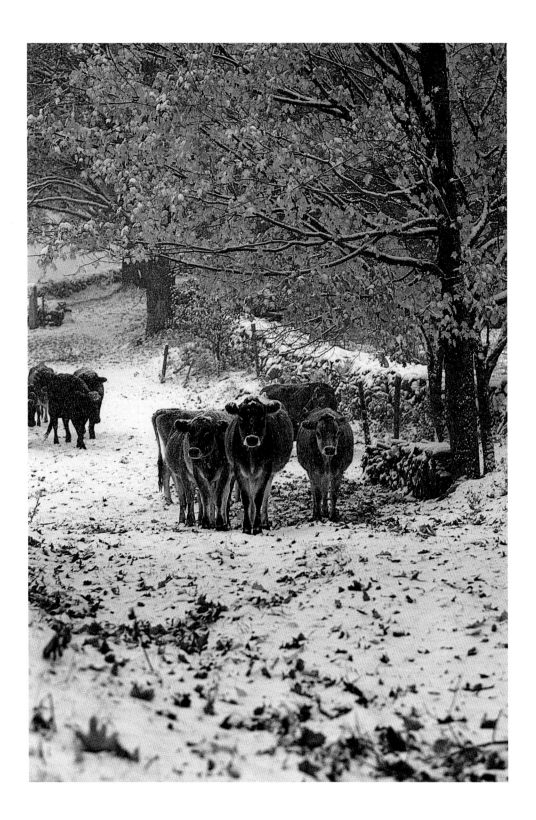

Previous, left:

Birch Grove

GUILDHALL

Previous, right:

November Hills

LINCOLN

Opposite:

Theron Boyd

QUECHEE

Left:

Early Snow

PEACHAM

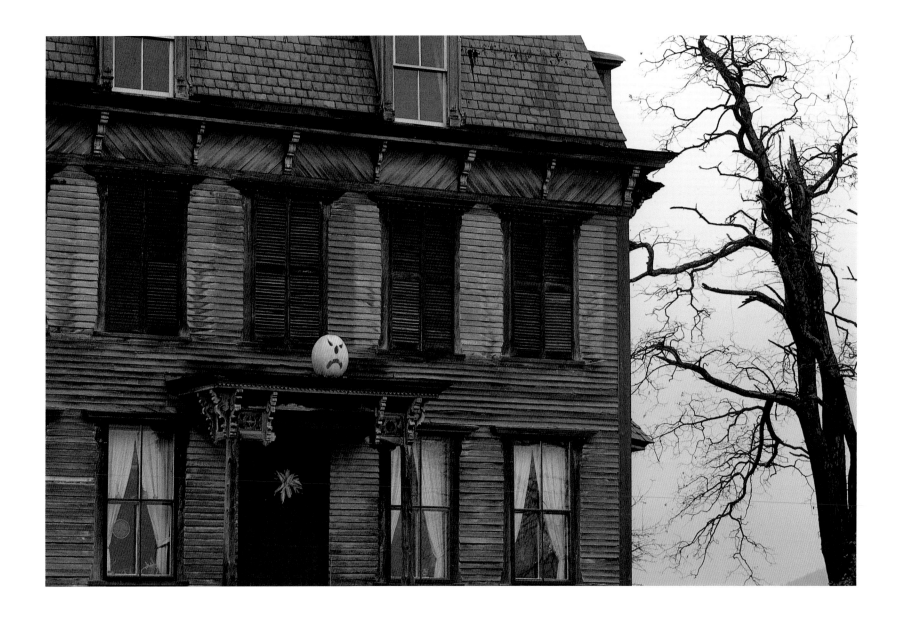

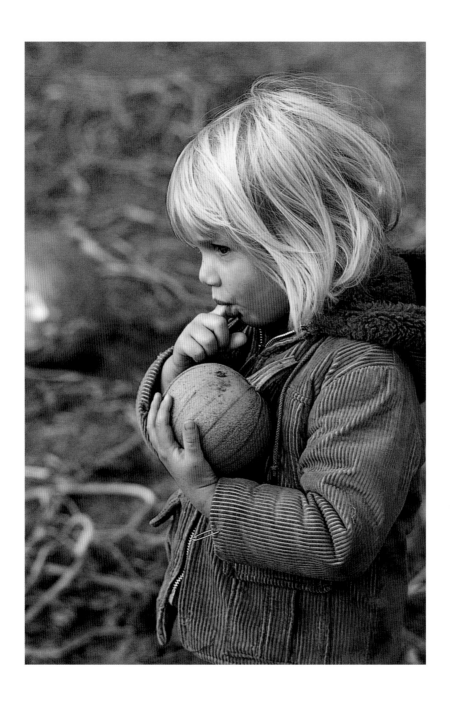

Opposite:
Haunted House

PLAINFIELD

Left:
Pumpkin Harvest

FAIRFIELD

Right:

Ancestors

QUECHEE

Opposite:

November Afternoon

WEST BARNET

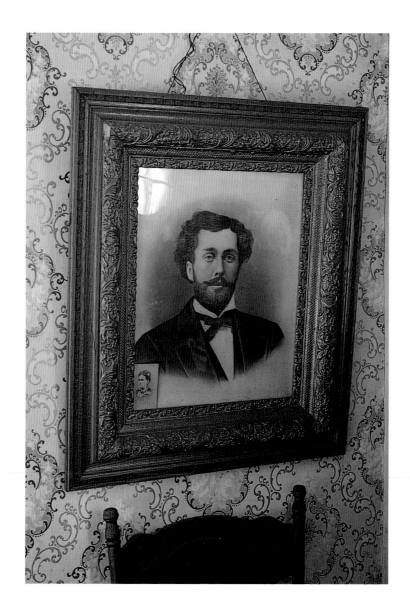

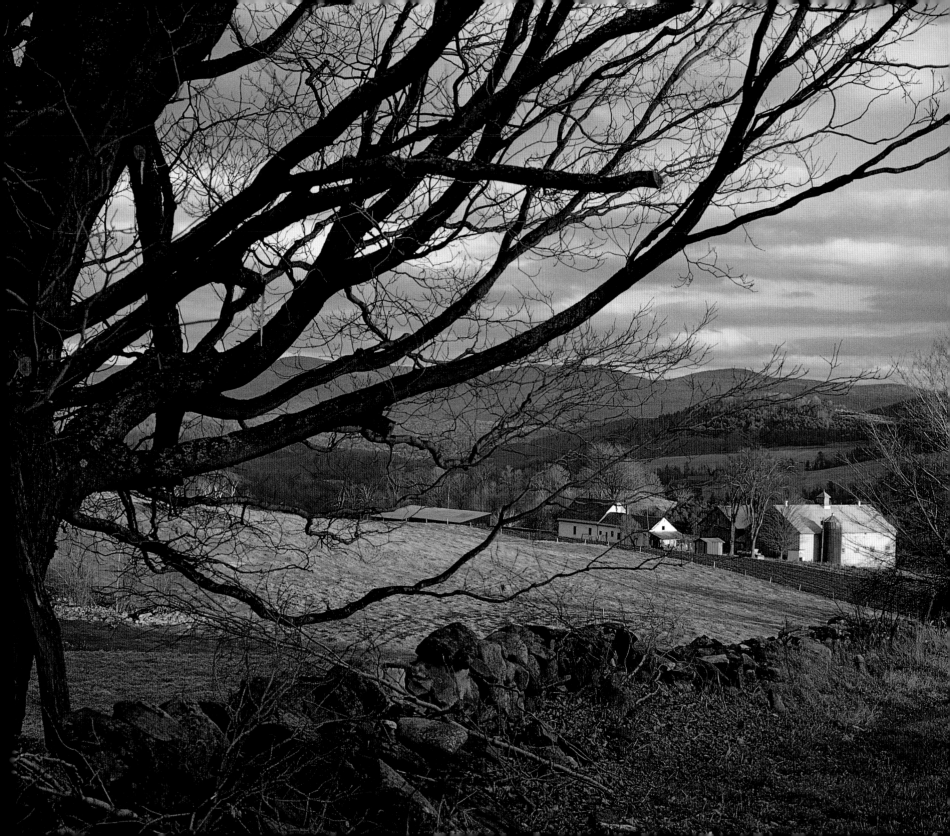

Lighting the Stove

PEACHAM

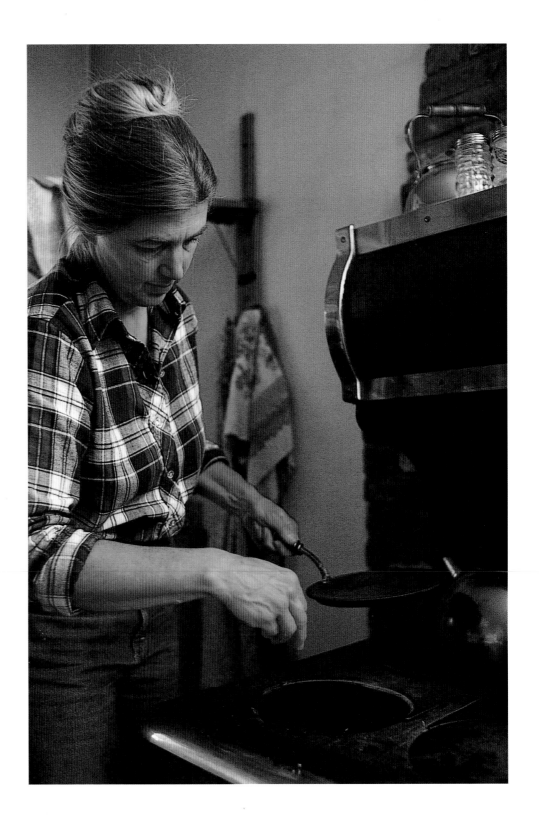

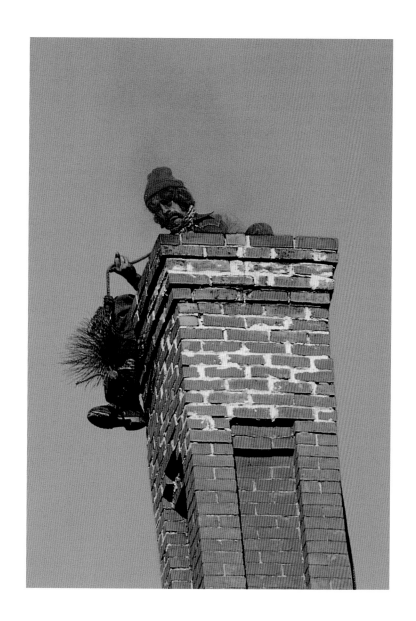

Chimney Sweep

RUTLAND

Spreading Manure

———

KIRBY

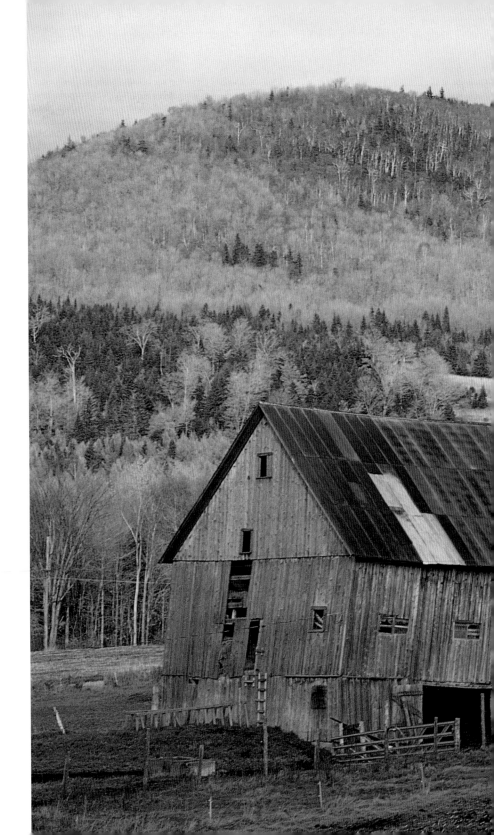

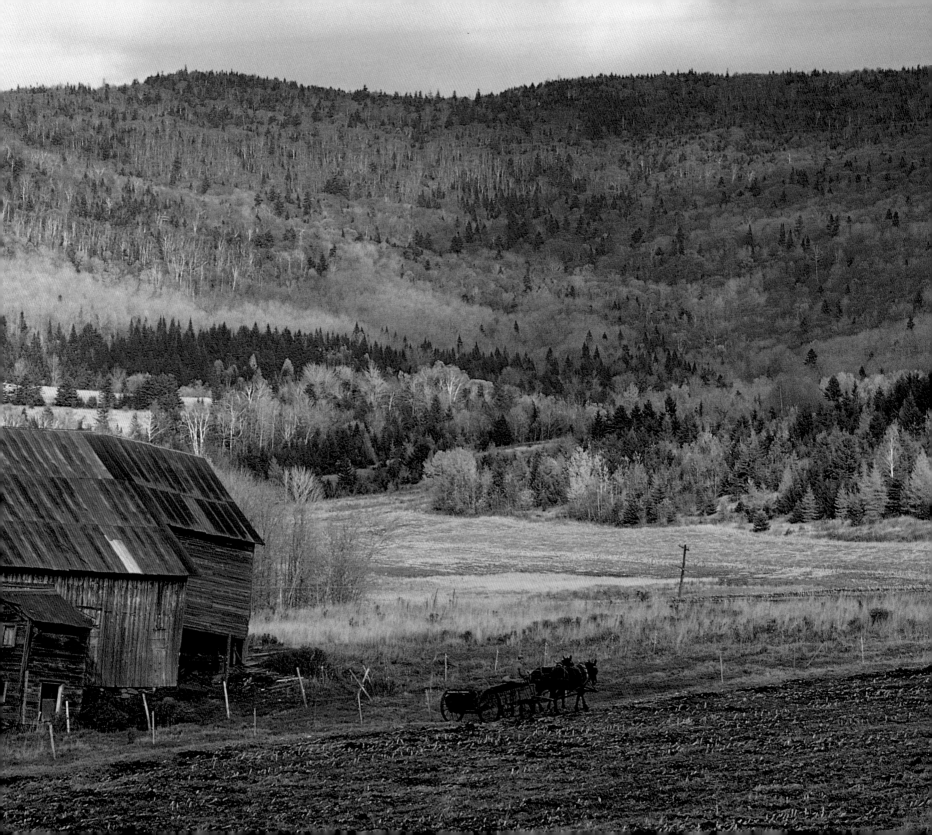

Meetinghouse cemetery
———
ROCKINGHAM

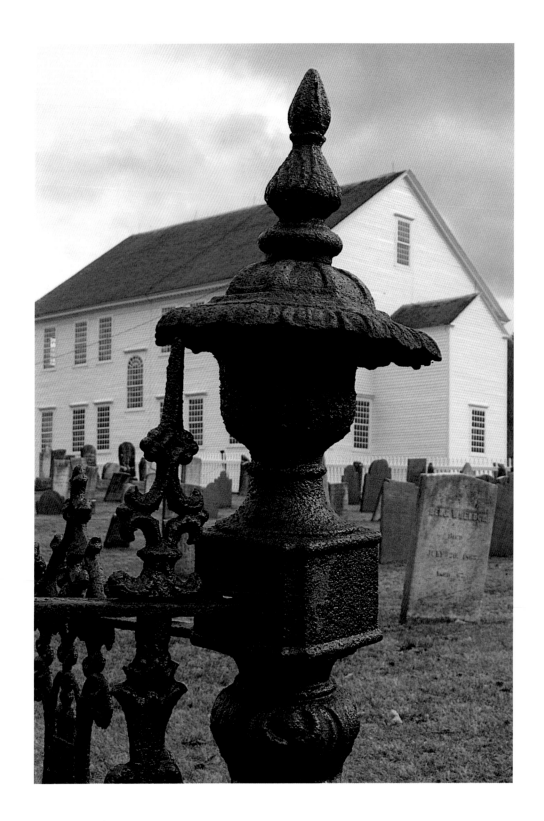

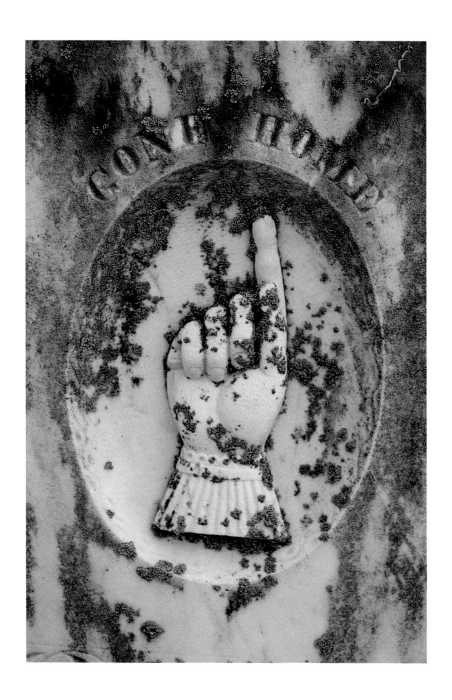

Gone Home

GRANDE ISLE

Right:

Ferns and Granite

WARREN

Opposite:

Mt. Mansfield

UNDERHILL

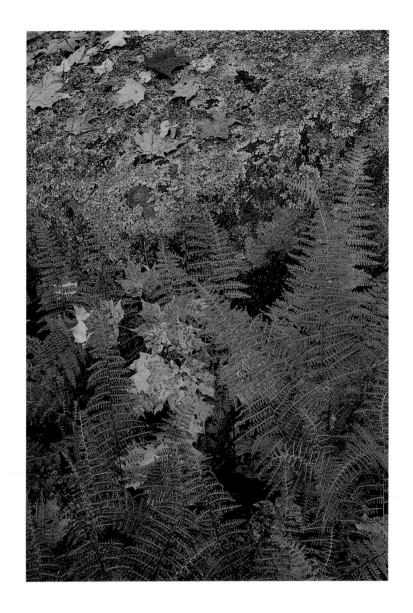

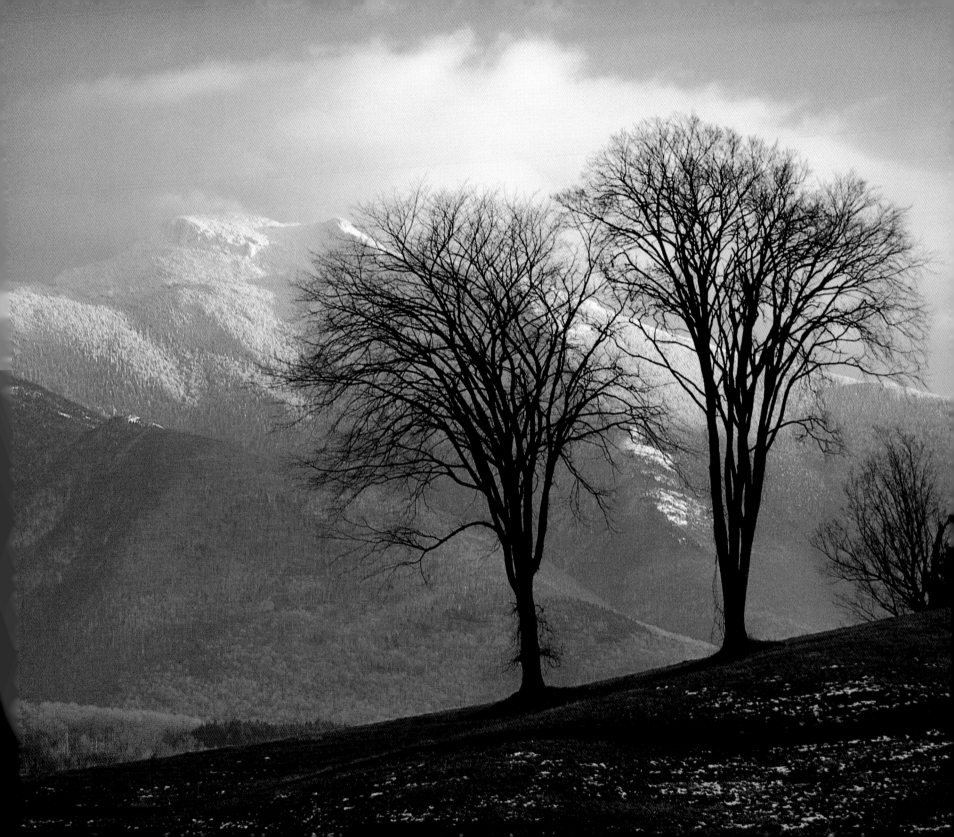

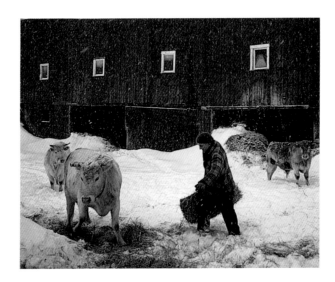

OLD MAN WINTER

THE BEST VERMONT WINTERS ARE THE ONES WHEN IT REALLY snows—serious, three-foot-drift, whiteout winters—not the limp-wristed kind we've been getting lately. To my mind nothing is more depressing in January than rain. It means knee-deep slush and vast pools of water with nowhere to go. And then, because it always gets bitterly cold after it rains, it means ice—the sort of ice that makes just walking from the house to the car fraught with peril. No, give me a cold winter, cold enough to make the snow squeak under my boots and my nostrils stick with every deep breath.

I want a winter I can be proud of, boast of, one that takes some effort to survive. Otherwise why live in Vermont?

The child within all of us still revels in the ultimate snow day. There's nothing like a real blizzard to make the rest of the world seem removed, unimportant, to bring on that delicious feeling of being snowbound. The big storms always seem to start late in the afternoon. All day it feels like snow, and the sky has that leaden, expectant look. By three or four o'clock the first snowflakes appear, just visible against the dark line of firs at the edge of the

pasture—not big, lazy flakes but the small, hard-driving kind that mean business. As darkness falls the storm picks up momentum. The outdoor light casts an opaque beam choked with churning whiteness. In the night the house shakes with the rumble of the snowplow as it thunders past, but by first light the road has filled in again, the plow's cut miraculously healed.

We wake to a Vermont transformed. The maples are giant white corals. The evergreens wear great paws of snow. Grosbeaks and bluejays assemble in squabbling hordes at the feeder; the storm makes them even more demanding and raucous. The cat watches at the window, hypnotized. Our dogs and children rush out the door, plunging into the abyss. For the morning this is their element. When they return they carry the smell of winter on their coats. The mud room clogs up with sodden mittens, leggings, and piles of boots, and small clumps of melting snow dot the floor. We revel in the contradiction—the freedom that being snow-bound brings.

I used to keep a small flock of sheep, a few hens, and some cattle in one corner of our dilapidated old dairy barn. Storm days meant wading through the drifts to check on their welfare. The animals needed feeding and watering, to be sure, and the eggs had to be gathered before they froze, but it was to savor that Noah's ark feeling of animal warmth and contentment in the midst of a raging flood of snow that was my prime motivation.

As soon as I clambered through the door, before my eyes had time to adjust to that dark world after the blinding whiteness out-doors, I was met by a cacophonous chorus of barnyard greetings. I was their provider, their savior, and they gathered round in sup-plication, bathing me with their warm breath. When I broke open the bales of hay and dumped clumps of June grass and fragrant timothy into the feeder, the essence of summer filled the dank midwinter air. Their chorus was immediately silenced, replaced by the gentler, reassuring sounds of feeding, the rustle of eager noses in the hay, the occasional clank of a sheep bell, the rhythmic chomping of bovine rumination.

I would sit back next to the lone window, rub the condensation from the glass with my glove, and glory in the moment. Outside the storm was just winding down, the snowflakes still drifting earth-ward, but slower now. Inside my motley collection of beasts was sheltered, fed, and happy—yin and yang, each world made more complete by its opposite, old man winter testing our mettle, Vermont as it should be in the nadir of the year.

Right:
Birch Trunks

WOODBURY

Opposite:
Fresh Snow

JACKSONVILLE

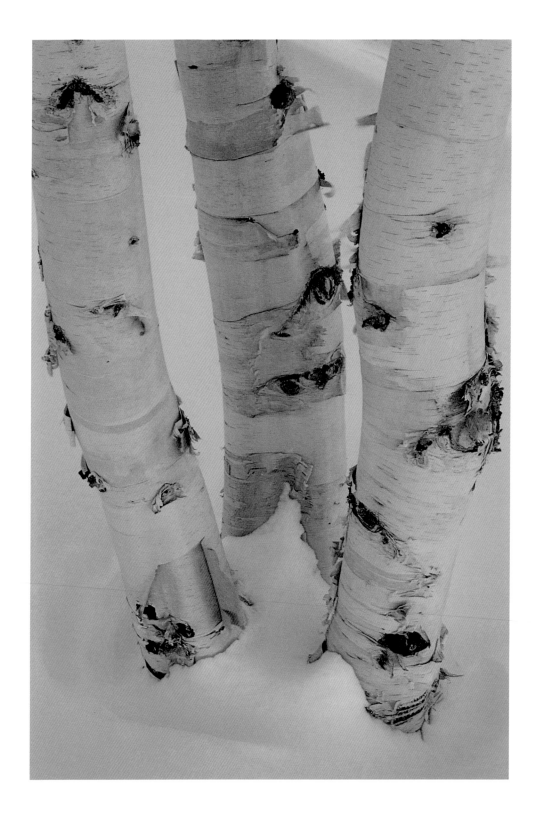

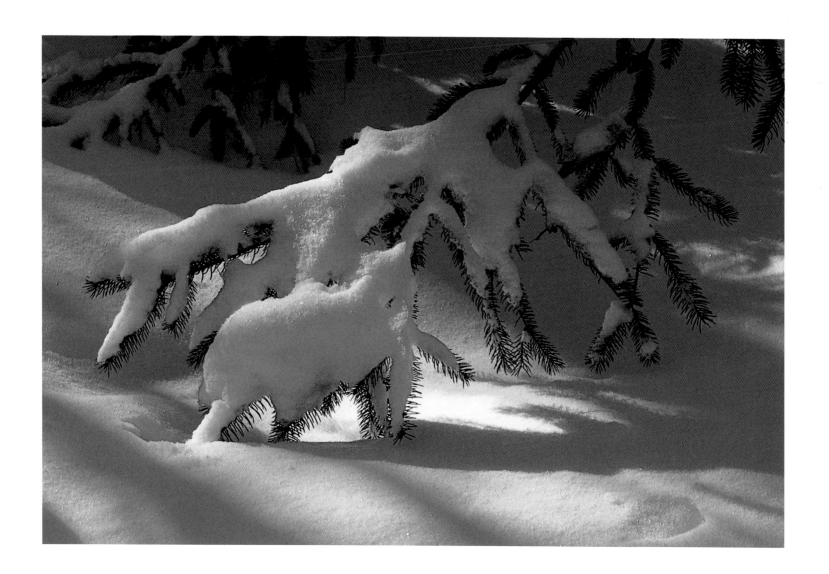

Wash Day
—————
PEACHAM

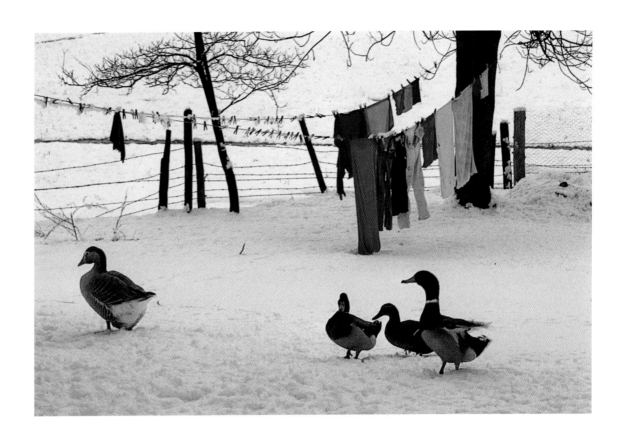

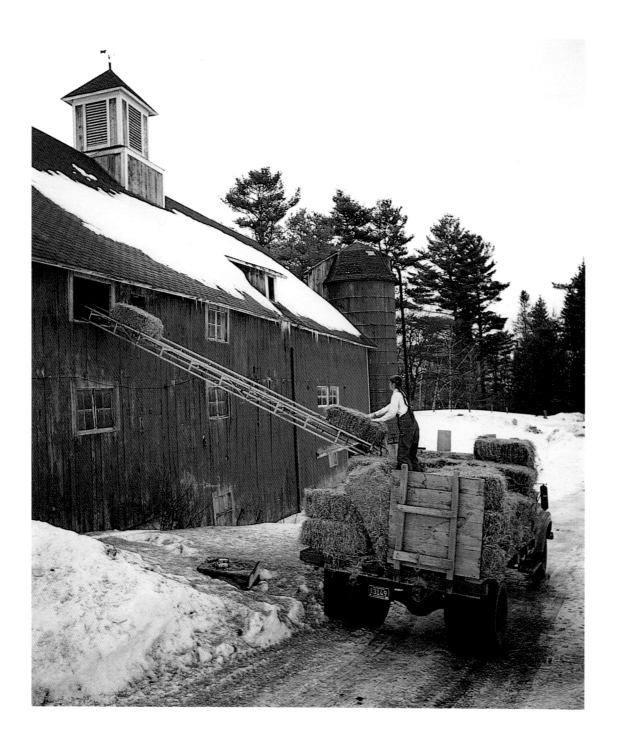

Bought Hay

RYEGATE

Right:

Singing Hymns

WEST BARNET

Opposite:

Evening Lights

EAST CORINTH

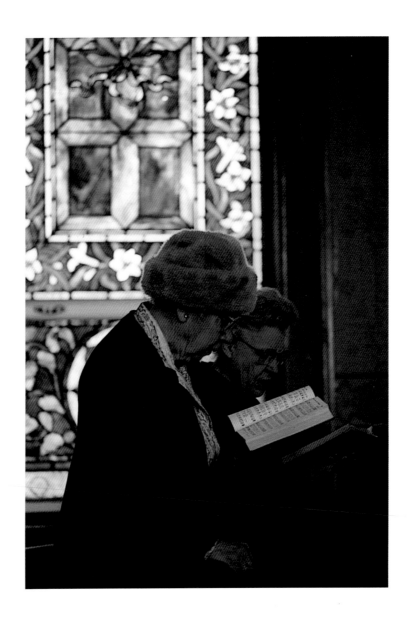

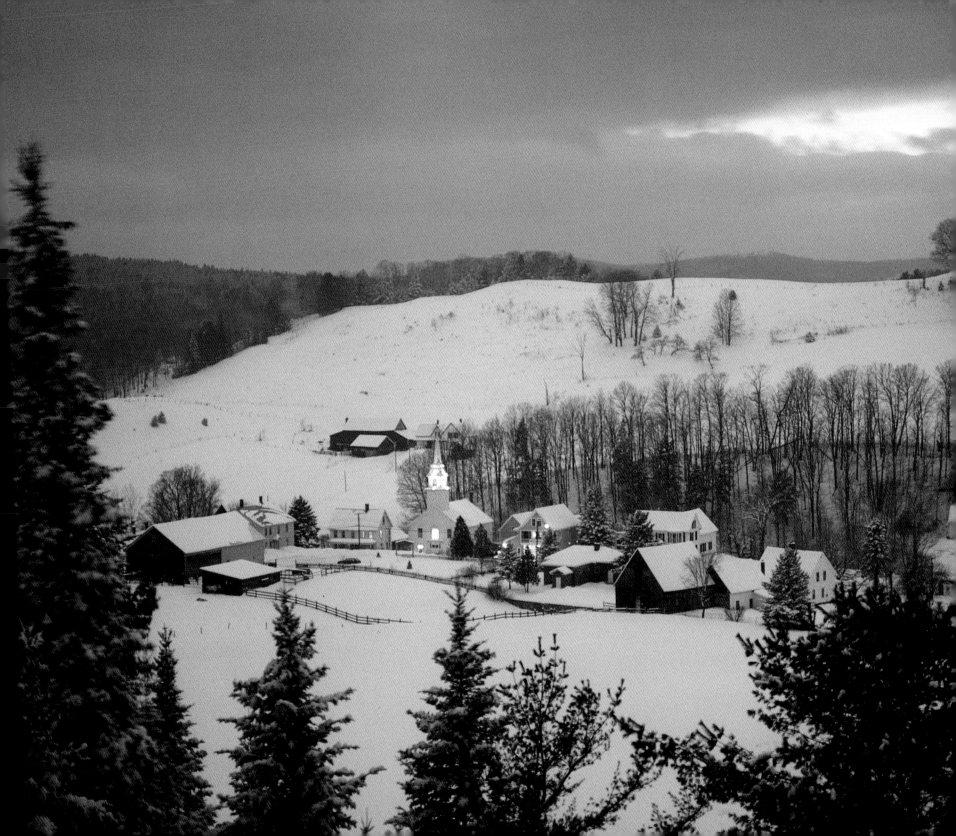

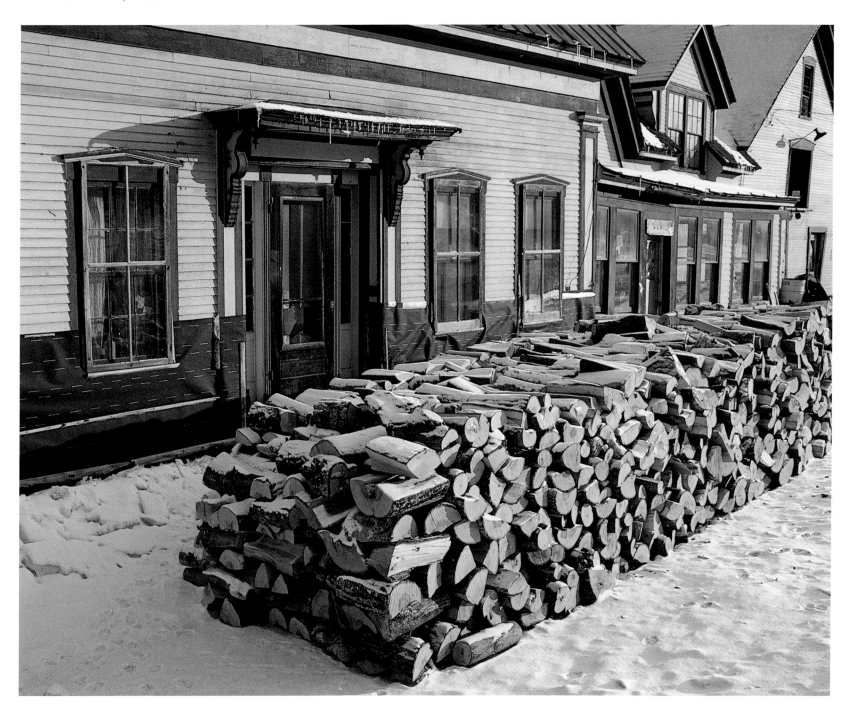

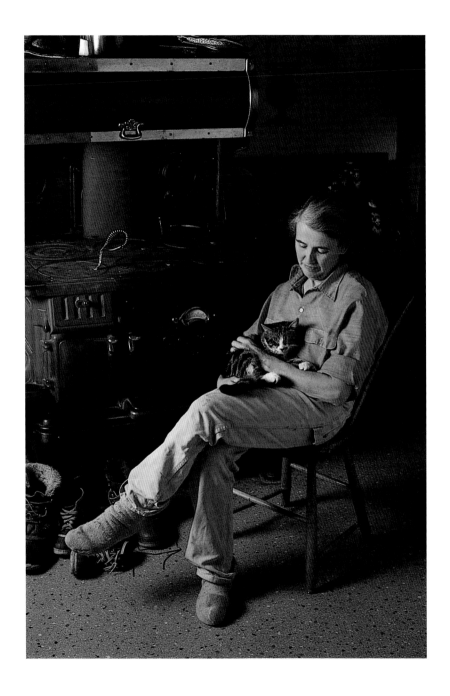

Opposite:
Woodpile

EAST HARDWICK

Left:
Keeping Warm

CABOT

Overleaf:
Well Below Zero

CORINTH

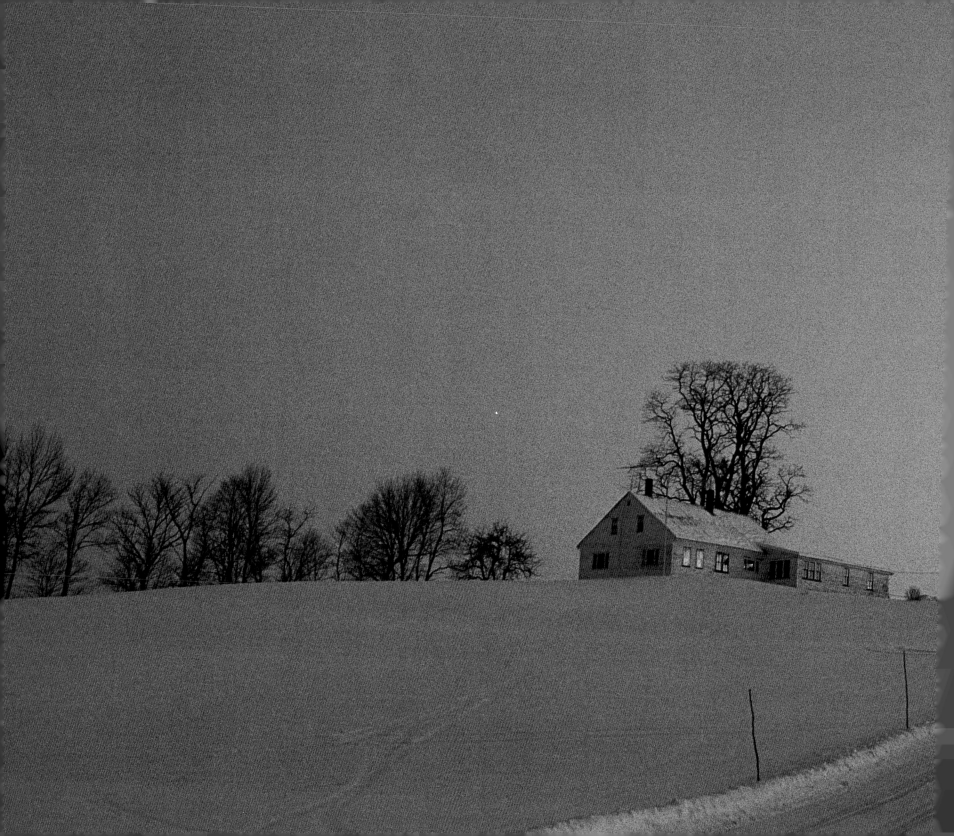

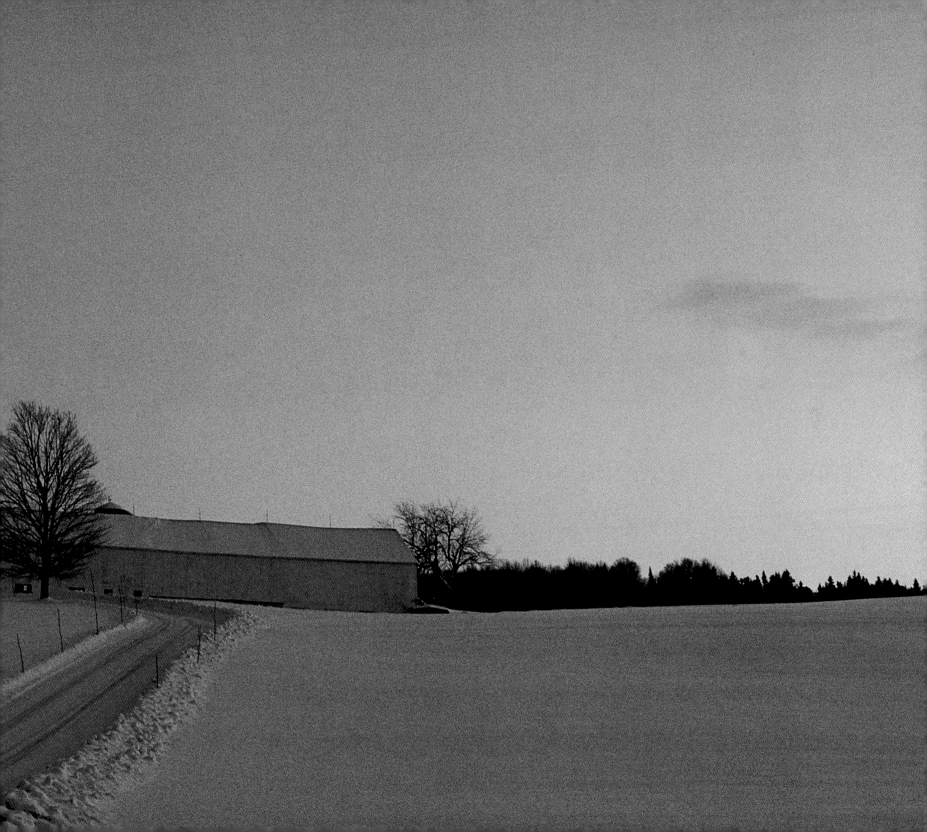

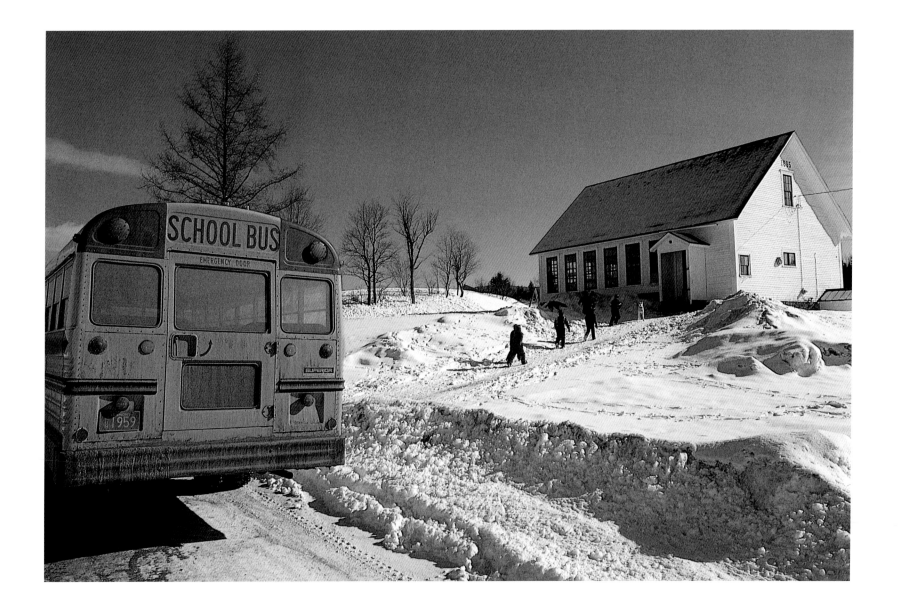

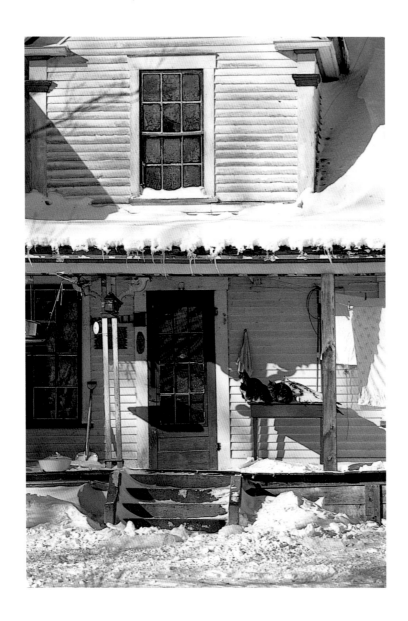

Opposite:
One-room School

WALDEN

Left:
Porch Cats

PEACHAM

Right:
John's Lamb

W E S T B A R N E T

Opposite:
Barnyard Flock

P E A C H A M

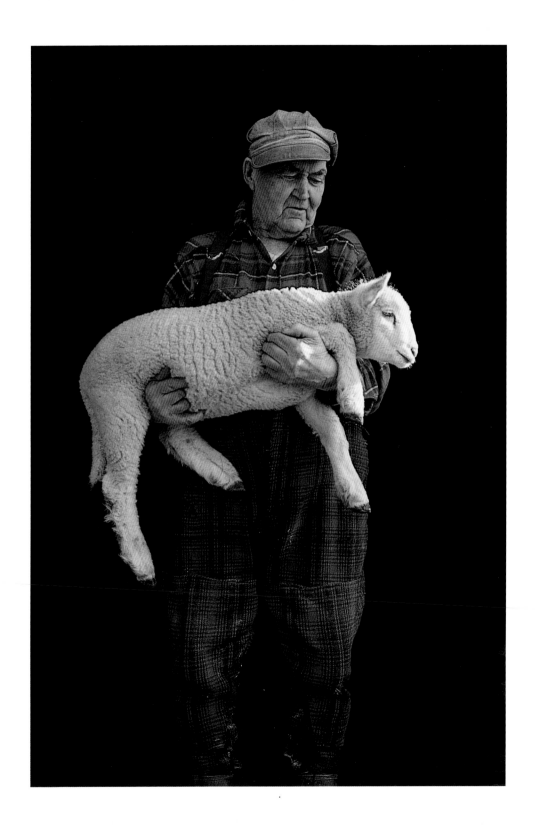

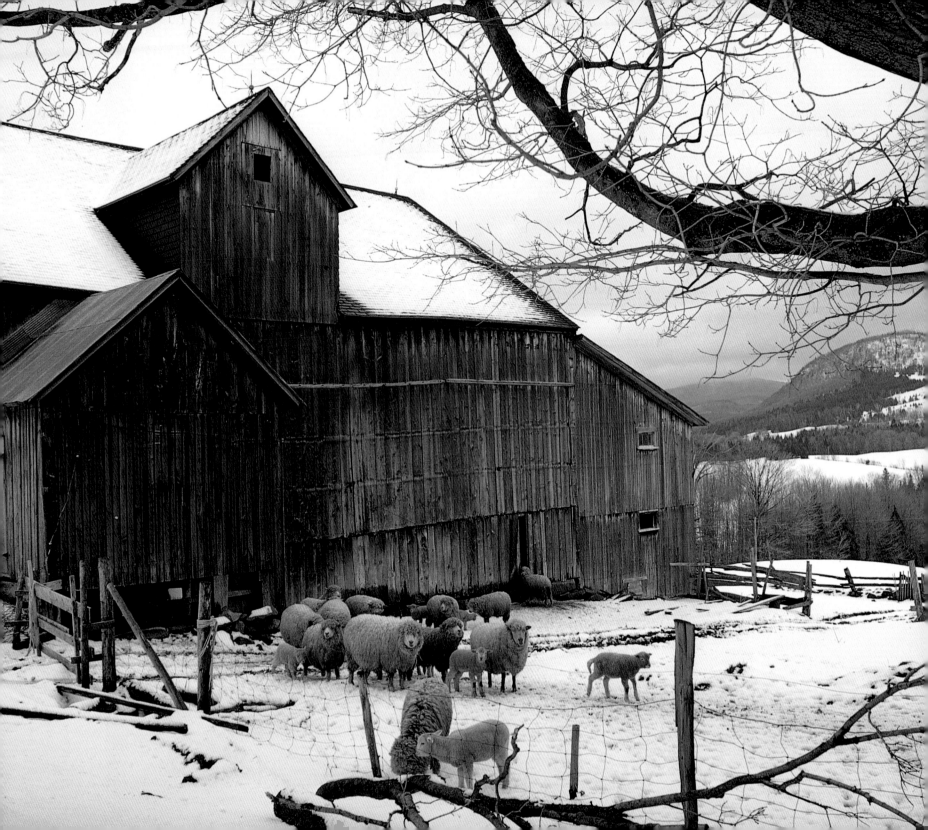

The Meeting House
————————
STRAFFORD

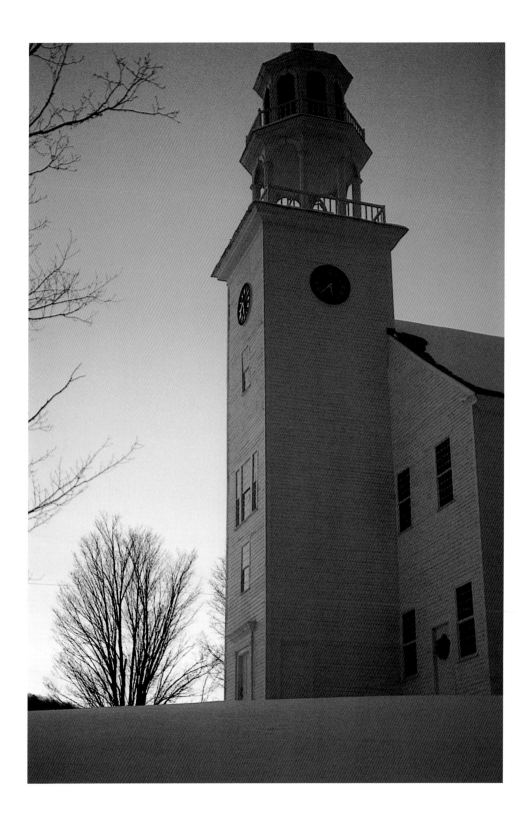

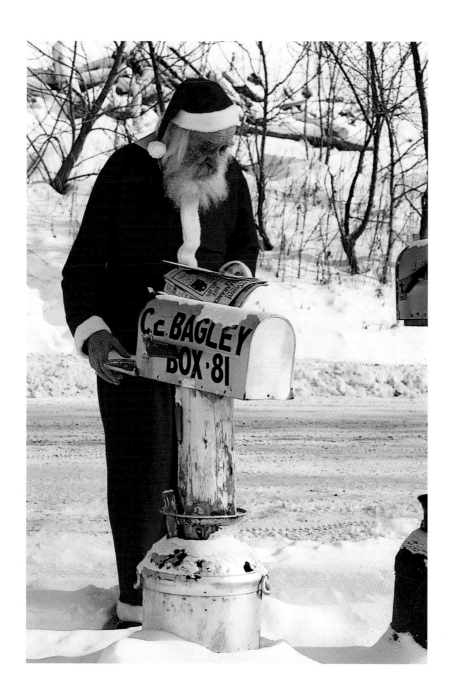

Santa's Mail
———
PASSUMPSIC

Right:

Shoveling the Roof

LOWER CABOT

Opposite:

Evening Chores

BARNET

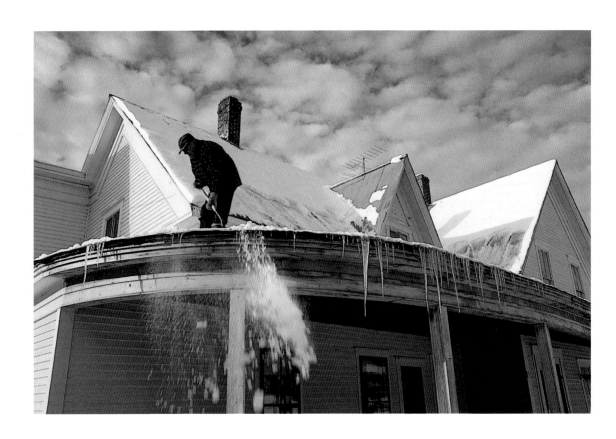

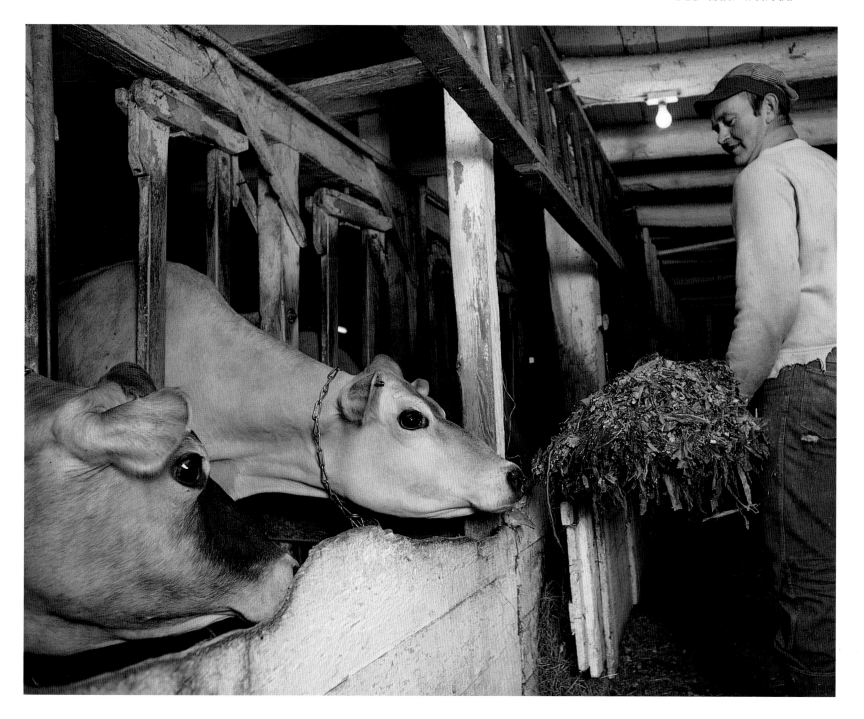

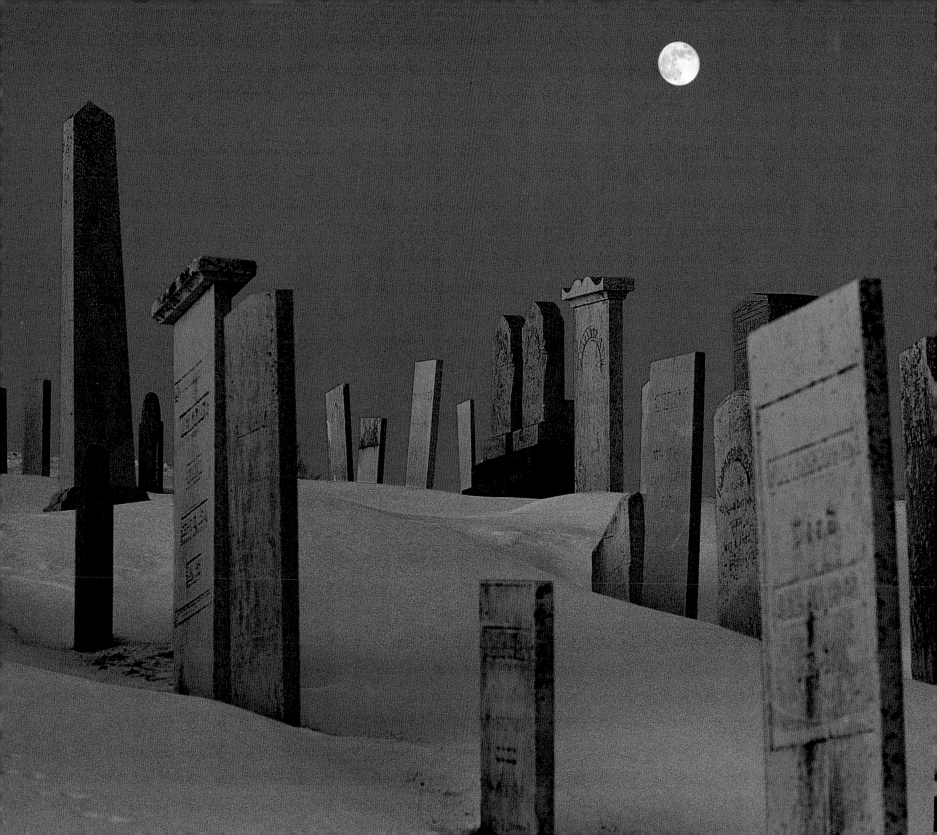

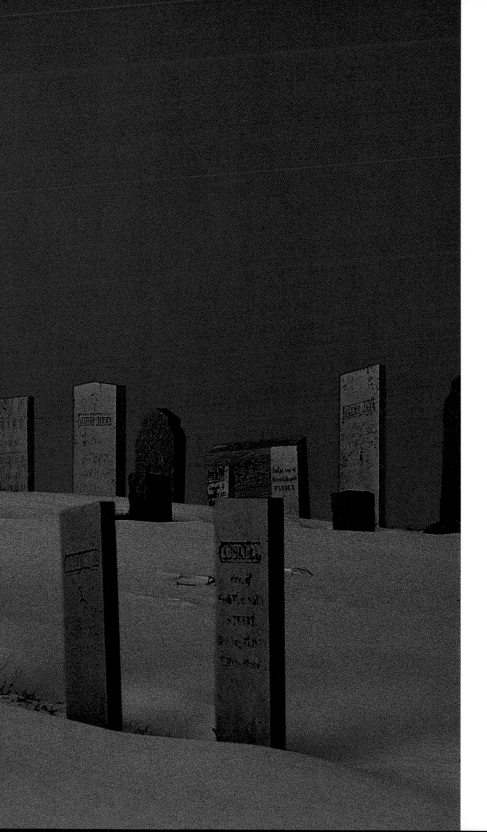

Moonrise

WEST BARNET

Village Sledding
———
W A I T S R I V E R

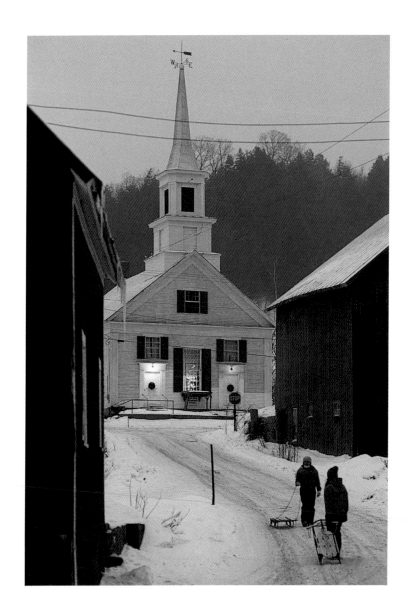

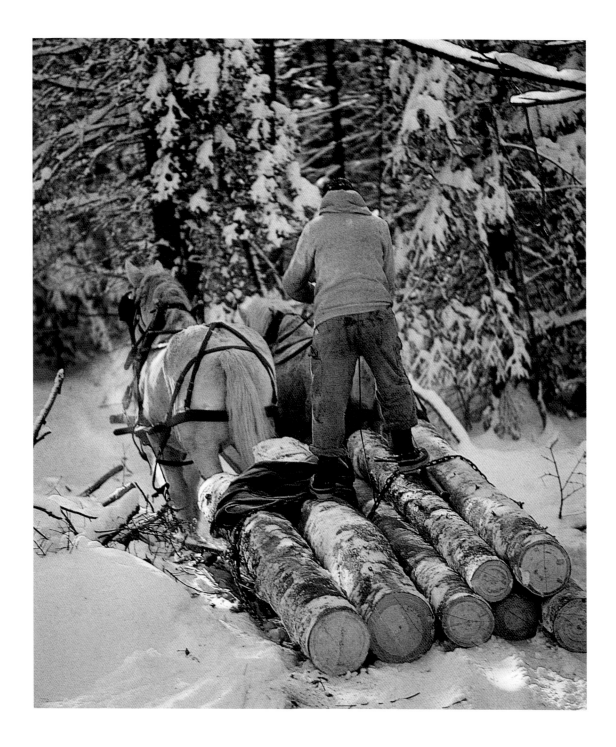

Last Hitch of the Day

CABOT

Right:
Covered Bridge

WEST
ARLINGTON

Opposite:
Paperboy

ST. JOHNSBURY

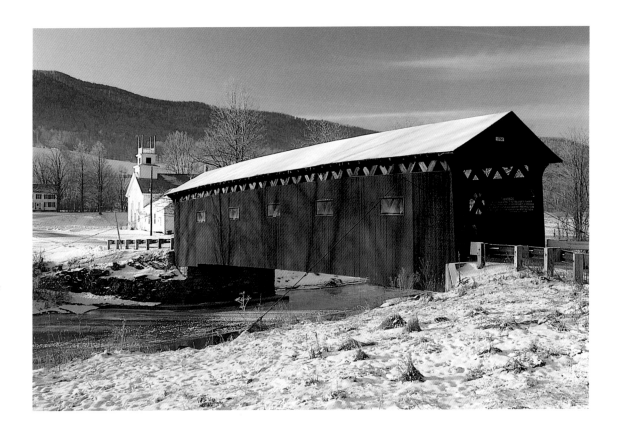

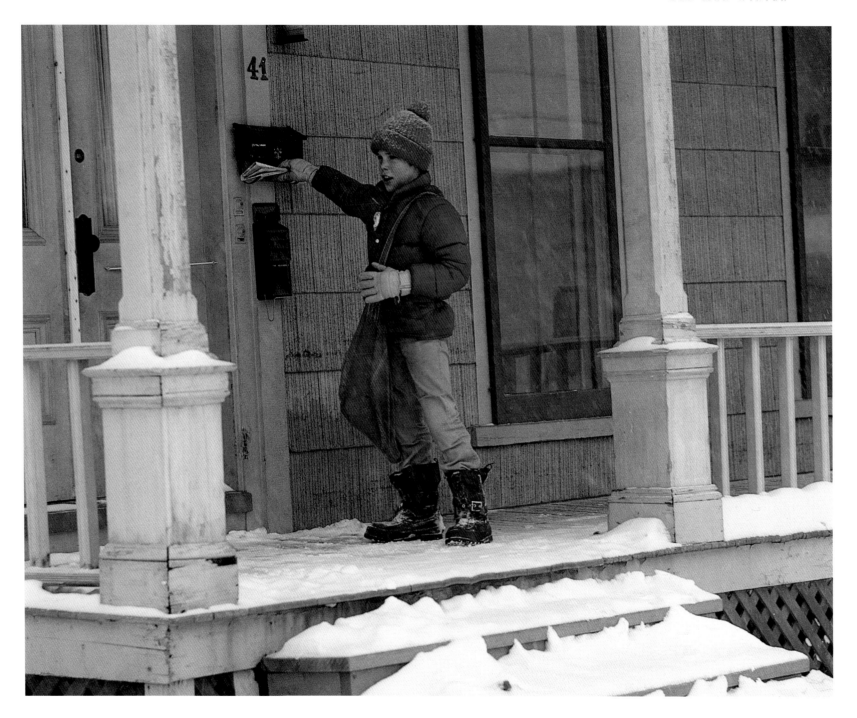

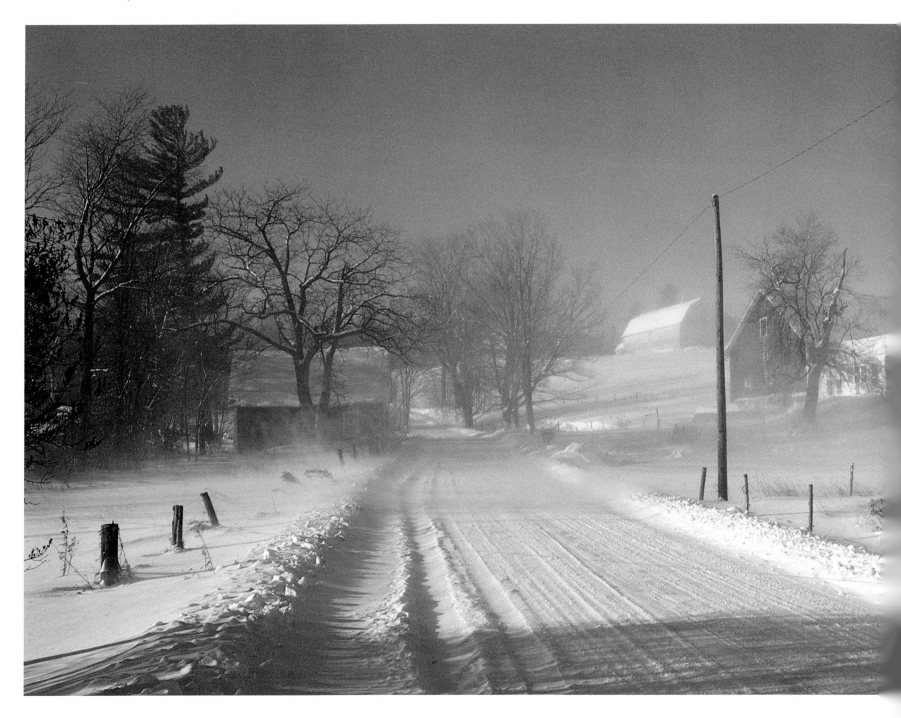

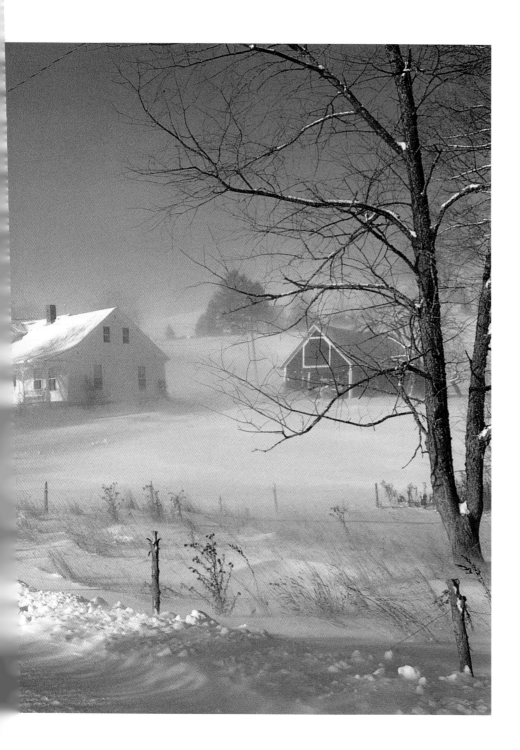

Drifting Snow

EAST PEACHAM

Right:
Roy's Sugarhouse

BARNET

Opposite:
An Aging Veteran

HUNTINGTON

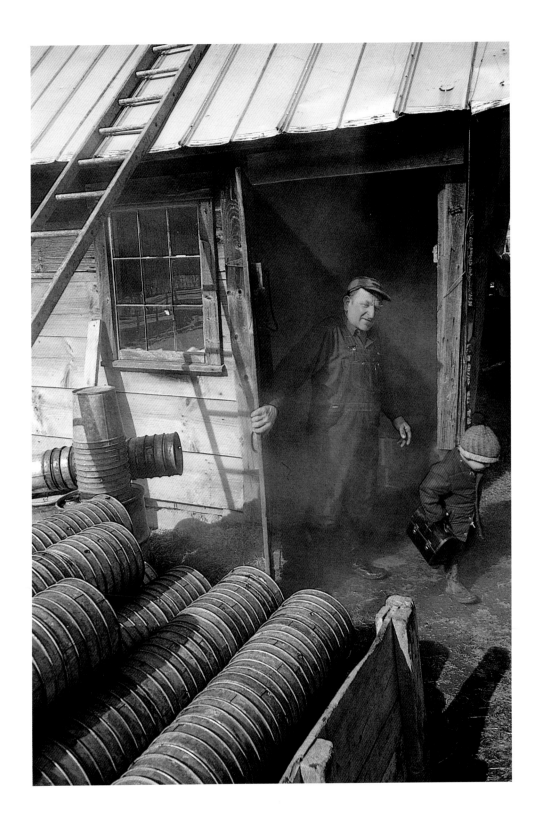

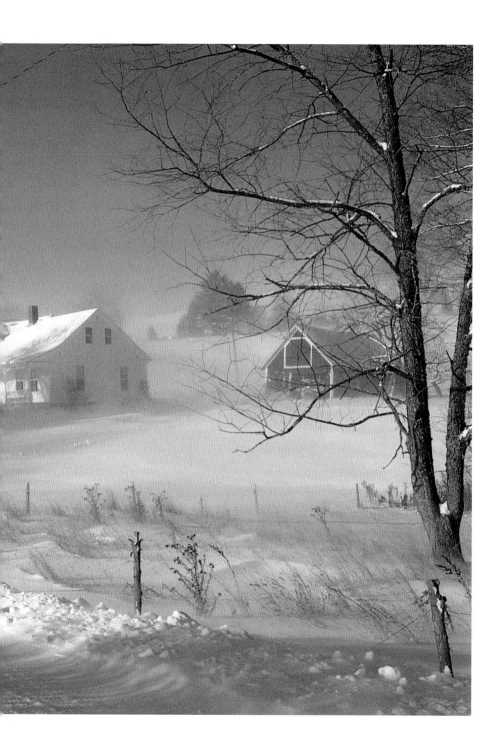

Drifting Snow

EAST PEACHAM

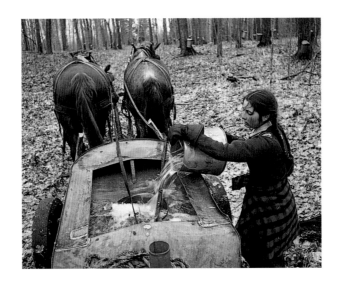

MUD *and* MAPLE

MOST PARTS OF THE COUNTRY ENJOY ROBINS AND PUSSY WILLOWS in March, but in Vermont we get mud. Not simply a little softening here and there but serious mud—a foot-deep, viscous, tire-sucking, muffler-wrenching, world-class glutinous pudding that is uniquely our own.

Mud season is our purgatory. We are stuck in a meteorological mire, caught between winter's eternal torment and spring's promise of redemption. Temperature and weather fluctuate wildly. There are days of dazzling clarity and infinite blue skies when the glare of melting snow is blinding, except where the old bull spruce and hemlocks stand in deep pools of violet shadow. There are days that recall the dead of winter, when a dull sky spits stinging granules of sleet and all hope is gone. And then, miraculously, there are days of intoxicating warmth, when a mourning cloak butterfly appears from who knows where, alights on a lone bare spot between the retreating drifts, and languidly opens its wings to the sun.

This is maple sugaring weather. All this fluctuation causes the sap to rise and fall in the maples like mercury in a thermometer.

This mud season ritual stirs the winter-weary soul as nothing else can, for at this time of year the sap begins to run in us all. In the sugar woods, normally taciturn Vermonters joke and trade mild insults with one another as they set to work tapping the maples and hanging the buckets. Even the behemoth draft horses that haul the sap sleds are giddy. Eager to be out of the barn, they playfully nip at each other like foals as they break open the gathering roads that snake through the sugar orchard.

Maple sap is Vermont's great homegrown elixir. Each March I used to hang a dozen buckets from the row of shade maples in front of the house. My daughters would help lug the sap inside to the stove, where it steamed away interminably. Eventually we made about a quart of syrup and most of the wallpaper in the house fell off. I told everyone it was something fun to do with the kids, but really it was so I could walk out the door and drink sap straight from the tree — just unhook the bucket from the tap, lift it up, tip it back, and take long gulps of cool, pure, sweet essence of spring. "Cleans you right out," the old-timers would say, like flushing out your car radiator each spring. "Purges you of all those toxins accumulated from four months of sitting on the parlor couch."

Inside the dimly lit sugarhouse the sap foams and dances in the pan. The syrupmaker throws open the cast-iron fire doors and feeds the roaring inferno with cord-length pieces of fierce burning junk wood — slabs from the local sawmill or leftovers from the pulp pile. His face quickly reddens and sweats until the doors are slammed shut again. He is Vulcan feeding the eternal flames.

Sugarhouses become noisy, egalitarian gathering places as children, dogs, farmers, lawyers, little old ladies, and Indian chiefs mingle goodnaturedly amidst the clouds of steam. Everyone has to test this year's vintage, "cutting the sweet" with something sour — pickled eggs or dill pickles — or pouring hot syrup on a handful of slushy snow.

In this misty setting, the usual social boundaries are blurred. And you never know what ghosts might be hidden in the swirling clouds of vapor — people you haven't seen for a year or maybe twenty, people you didn't even think were still alive. A sugarhouse boiling away at full tilt is a magnet for every lonely soul, banished spouse, parolee, and ancient, bearded hermit who's gone "woods queer" — in short, every winter survivor coming out of hibernation who is ready for a party. There's something in the steam, some sort of maple mood enhancer that lowers inhibitions and loosens everybody up. A neighbor who has weathered at least eighty Vermont winters once confessed to me amid the fragrant fog, her thin voice rising above the raucous laughter and the snapping of the burning wood: "You know, I don't mind dying, but I'm sure going to miss sugaring!"

Right:

Roy's Sugarhouse

BARNET

Opposite:

An Aging Veteran

HUNTINGTON

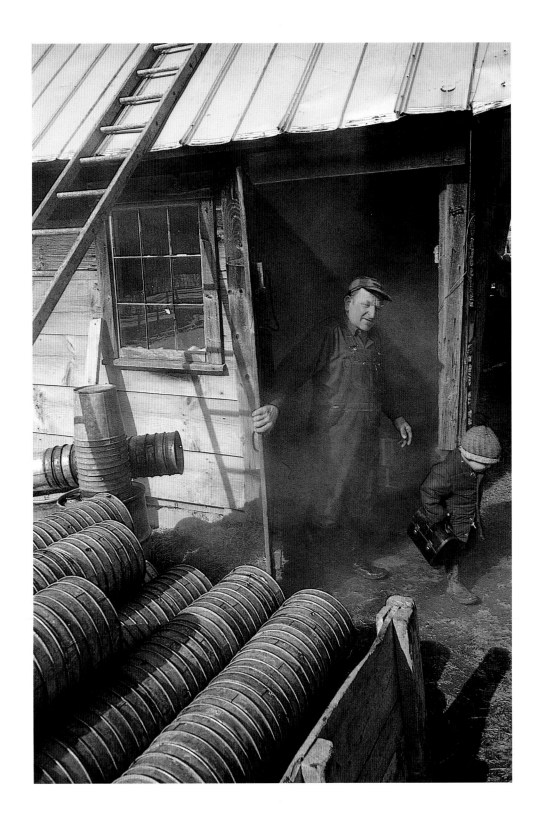

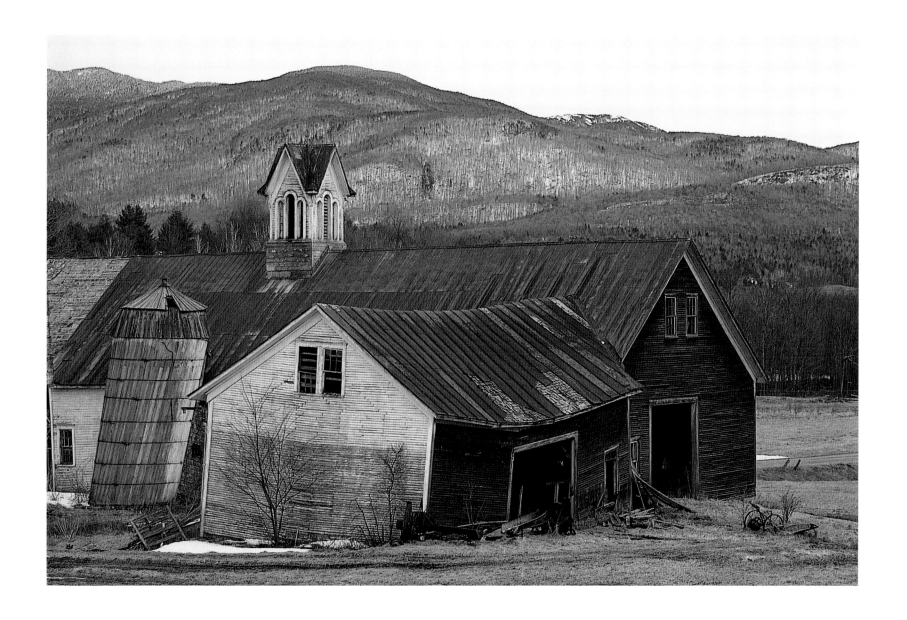

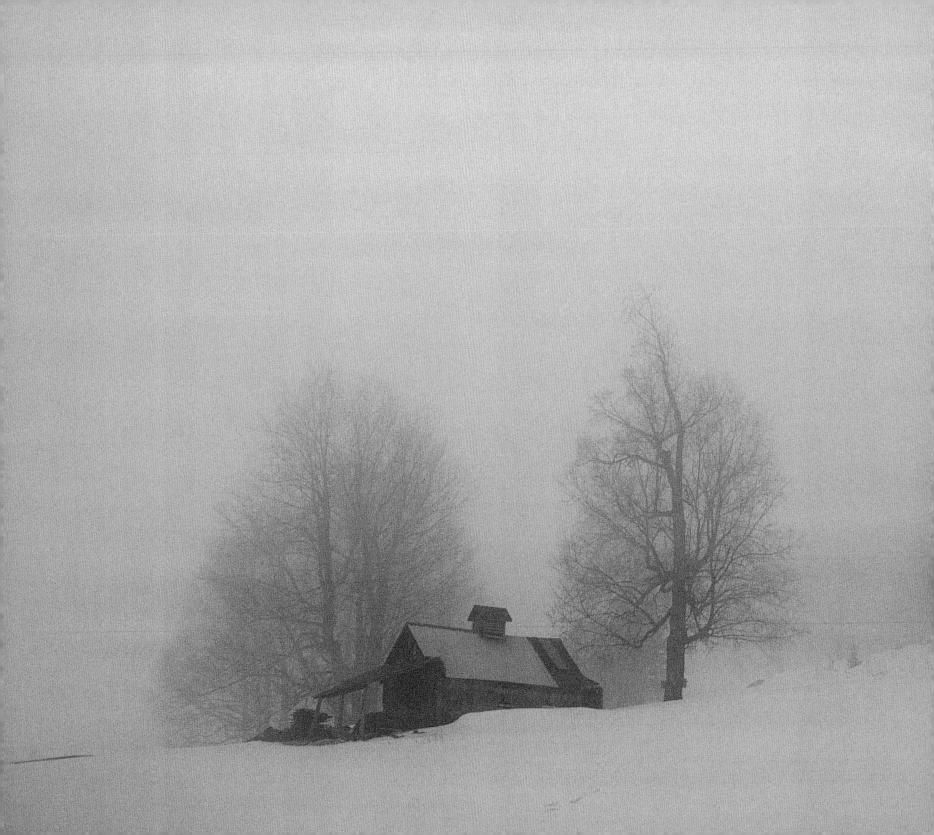

Thaw

P E A C H A M

Right:

Boiling Sap

BARNET

Opposite:

The Ox Man

PLAINFIELD

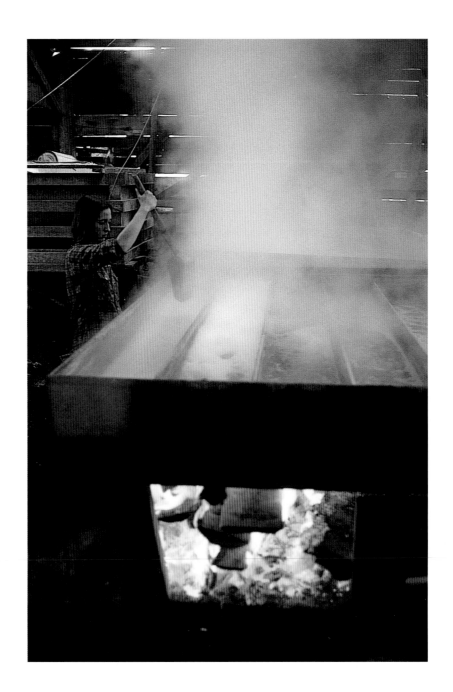

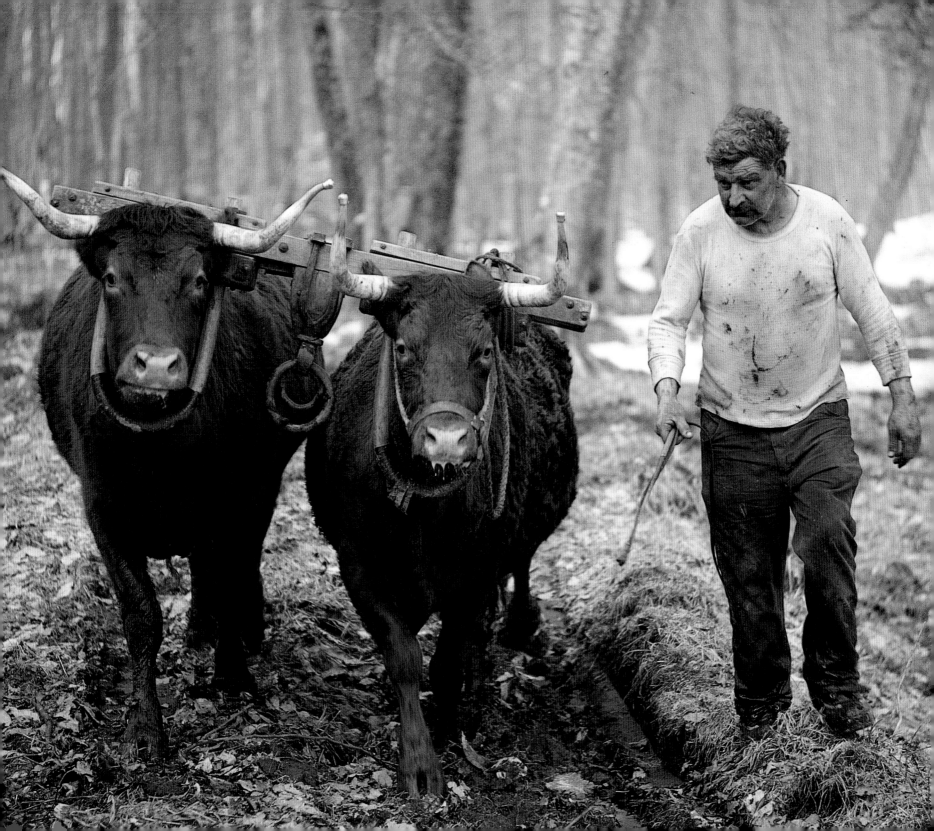

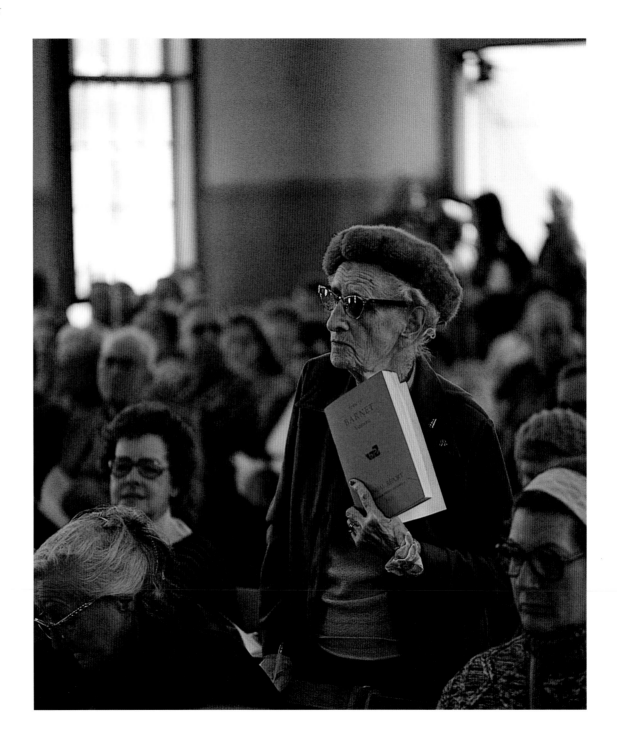

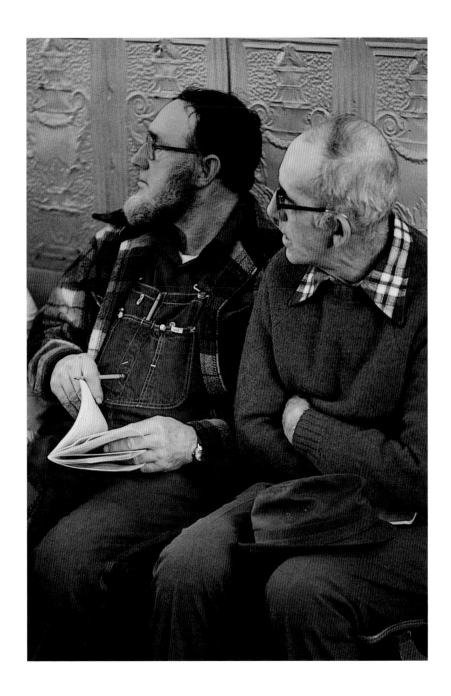

Right:

Herding Geese

———

BARNARD

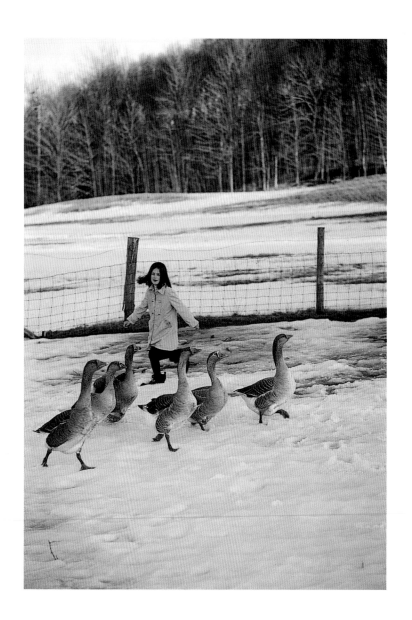

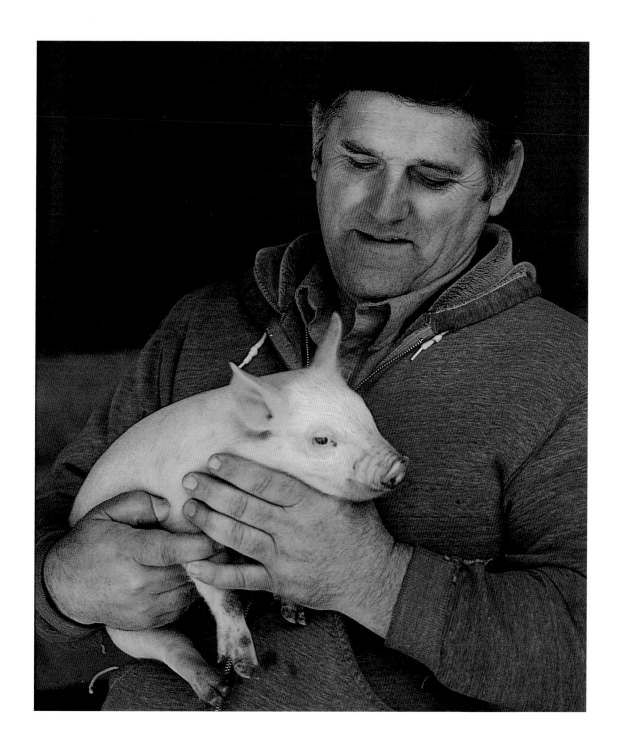

Left:

This Little Piggie

———

ADDISON
COUNTY

Overleaf:

Peak Mud Season

———

PEACHAM

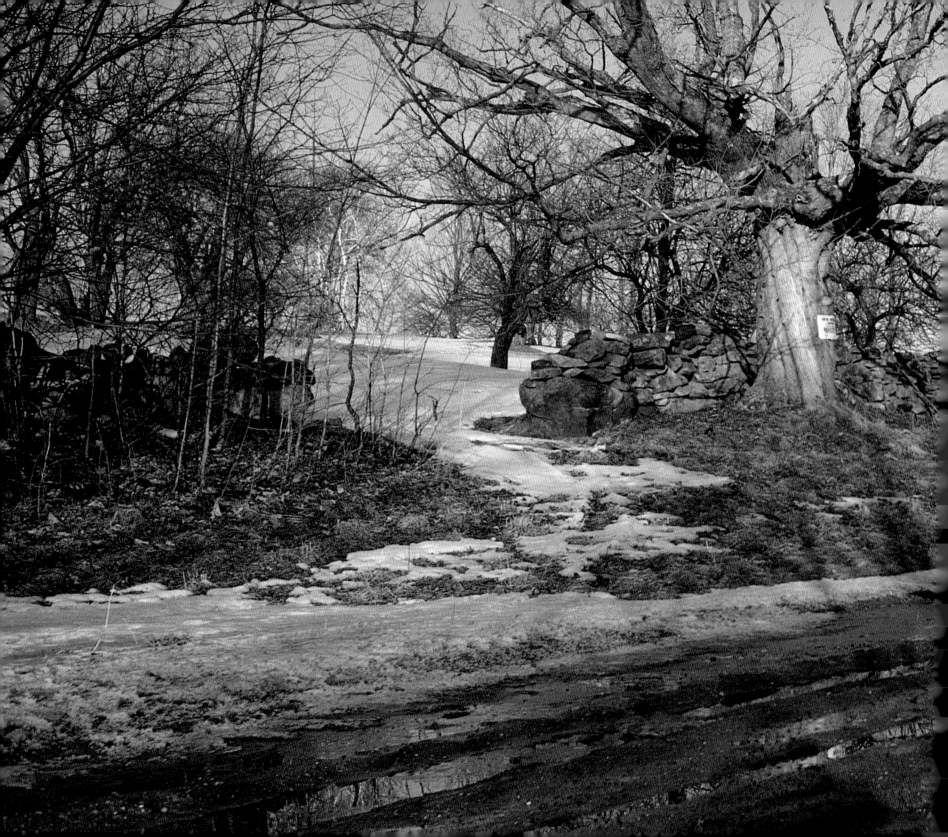

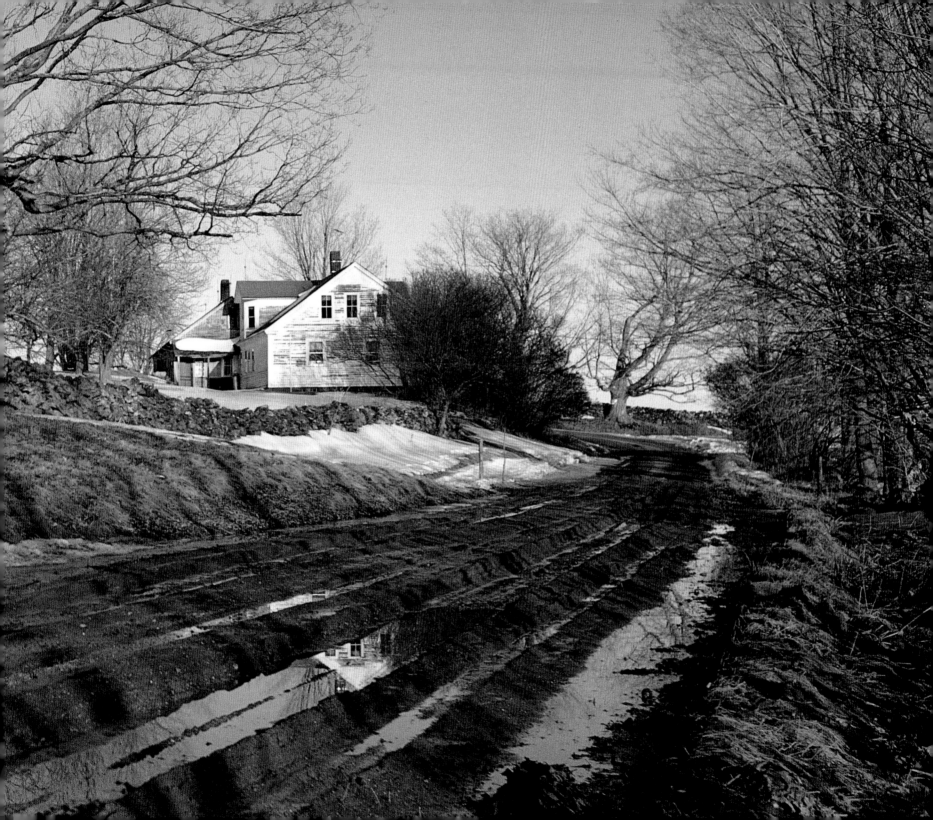

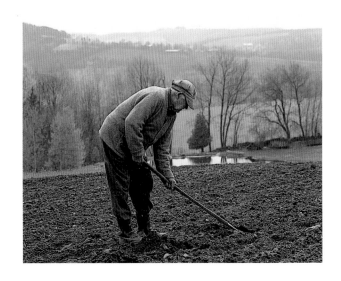

Ah, SPRING

WE VERMONTERS WHO WAIT INTERMINABLY FOR SPRING TO arrive find solace in so-called "first signs," any faint hint that winter's grip is weakening: hardwood hillsides that begin to show a subtle violet tinge, perhaps, or the chickadees' familiar chatter giving way increasingly to their clear, two-note courting song.

I much prefer the "lasts," however: the last night below freezing, for instance, or the last visit of the oil-delivery man. I long for the last time I have to pull on the long underwear or the felt-lined Sorels, and, sweetest of all, the last morning I have to get up in the dark to coax what little remains of last night's fire into rebirth in our asthmatic wood stove.

Finally, sometime in early May, after weeks of foot-dragging and sulking, spring explodes. Everything happens on fast-forward. One day we're scraping frost and road salt off our windshields, the next day we're scraping off a multitude of splattered insects. Yesterday the tree buds were just beginning to redden and swell, today they are sending forth a green haze of unfurling leaves. Tomorrow there will be a verdant canopy

overhead, and the world will be a different place. This is our *other* foliage season. The red of the soft maples mixes with the pale silver-green of the poplars, the soft yellow of the oaks, and the bright lime green of the beeches. The trees' uppermost branches stir with momentary flashes of much more brilliant color: bluebirds, scarlet tanagers, indigo buntings, and orioles — exotic, tropical-seeming birds for this countryside so recently shivering with cold — gaudily attired torch singers pouring their hearts out at 4:00 AM.

In one week we cross the line from not nearly enough spring to almost too much. We look longingly for those first tender shoots of green pushing valiantly through last year's dead and matted growth, only to curse them soon after, hopelessly behind with our mowing. It isn't even Memorial Day, and the lawn waves in the wind like a Kansas wheatfield. My surly LawnBoy starts on the one hundred and twenty-first try, and then is so uncooperative it's hardly worth the effort. It makes a big point of choking and stalling at every opportunity, leaving a sour-smelling trail of monstrous, wet grass clumps in its wake.

The moment I know spring is here for sure is when I reopen the front door. Like all Vermont farmhouses, ours has two entrances: the door at the messy end of the house that everyone uses, and the formal front entrance that is sealed shut for the winter. This is a vestigial door, once used, I imagine, for visiting in-laws, weddings, funerals, and the like. It is supposed to impress and make a welcoming architectural statement. It now faces a road long abandoned on the far end of the house, so it is invisible to any visitor and even more useless than most front doors. Its saving grace, however, is that it opens onto a wide and gently sagging porch, the kind of genteel feature you still see clinging to the front of many older homes.

By the second or third week in May I can stand it no longer. The door is stripped of its insulation and tar-paper and thrown open. The browned Christmas wreath that has hung from it these many months is taken down (true Vermonters leave their outdoor Christmas lights up year-round) and the odd collection of porch chairs and the old piano bench that serves for a table are reinstalled. As evening falls I once again take my perch in the venerable Boston rocker. The air is beginning to cool and the Jersey heifers, now let out to pasture, are placidly grazing beneath the full-budded apple trees out in the orchard. The occasional distant rumble of a car on the gravel road at the foot of the hill mingles with the liquid notes of a hermit thrush and the occasional thump and bang of a fat June bug bouncing off one of the window screens. This is heaven. Spring has officially arrived.

Right:

Black Lamb

WESTMINSTER

Opposite:

Spring Plowing

NORTH
DANVILLE

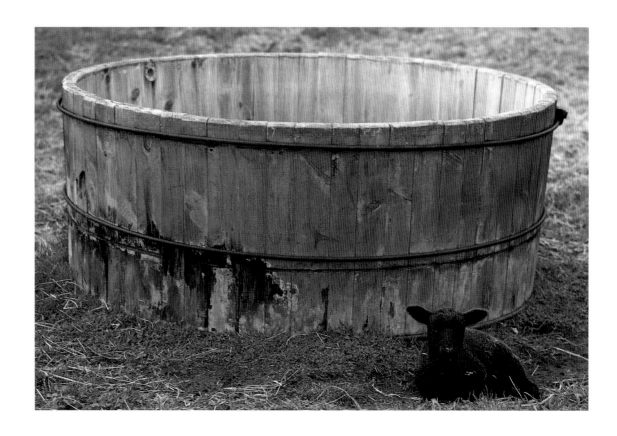

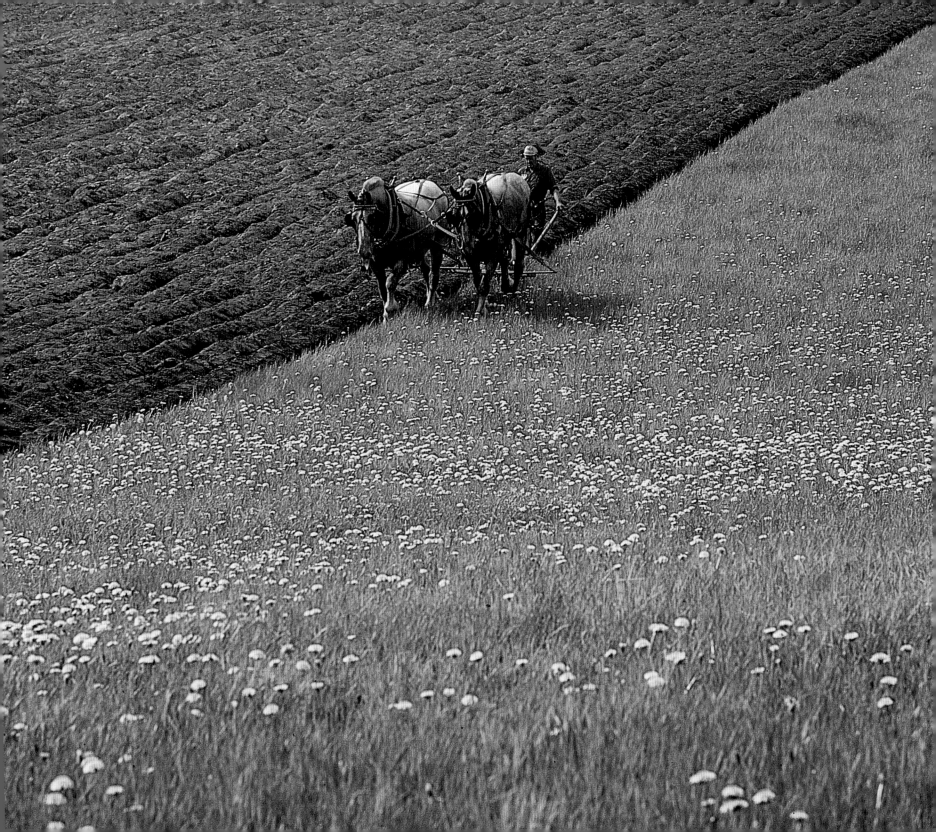

Moss Glen Falls

GRANVILLE

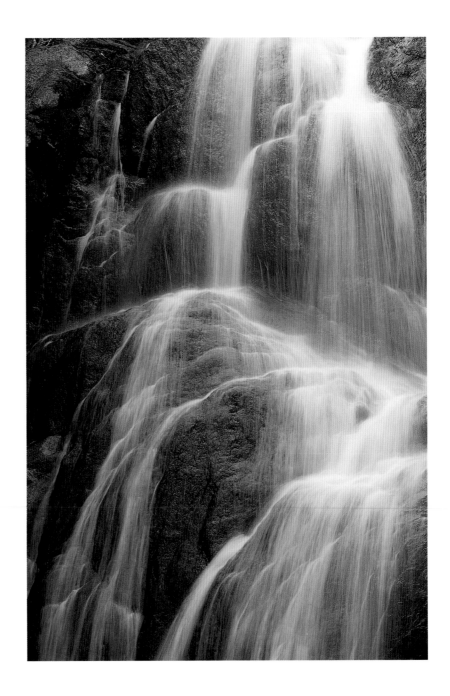

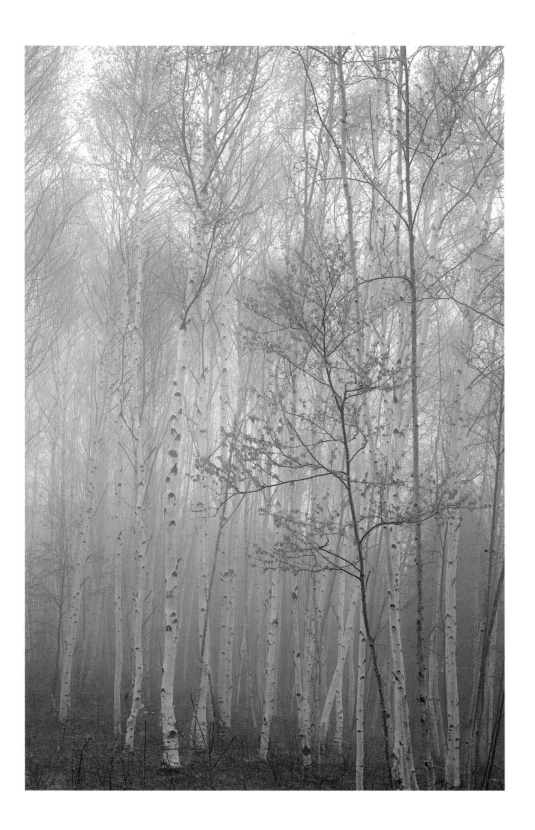

First Leaves
———
LUNENBURG

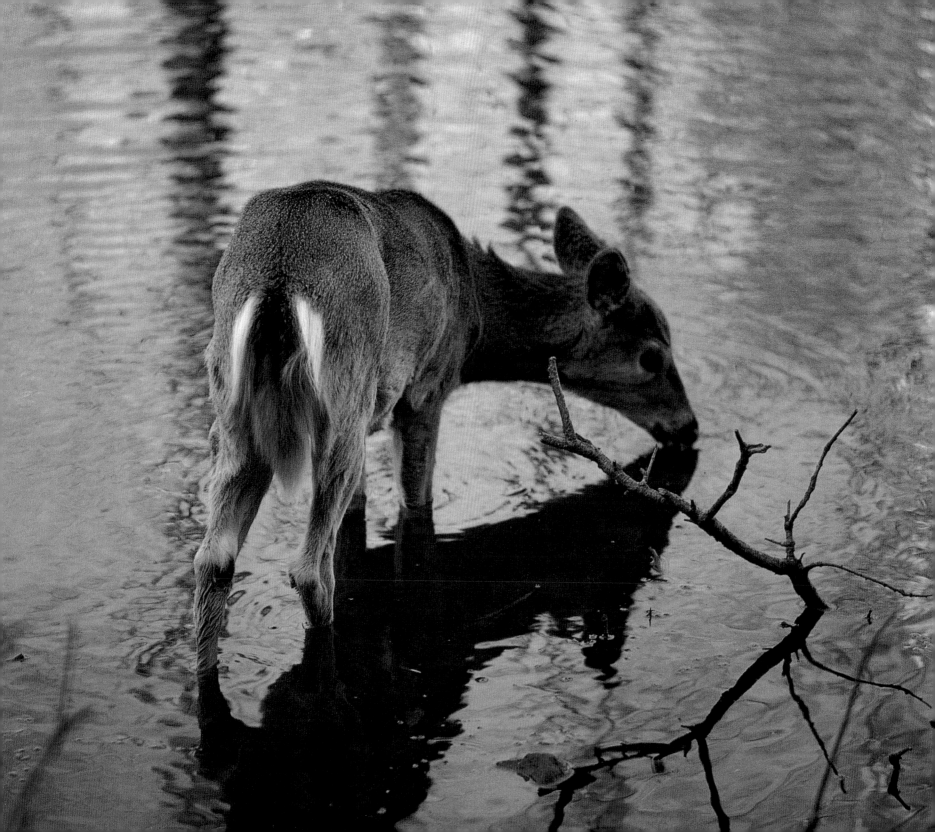

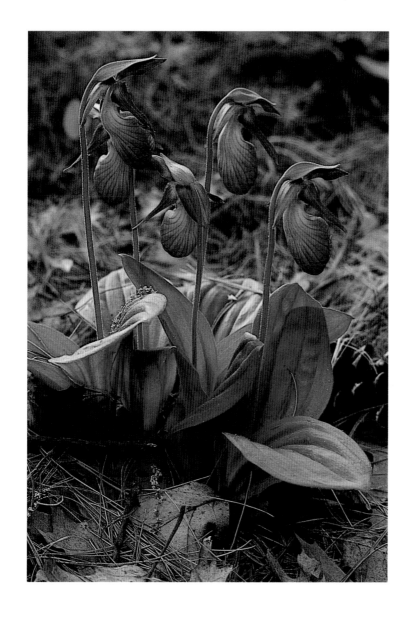

Left:
Pink Lady's Slippers

BRADFORD

Overleaf:
East Hill Road

BARNET

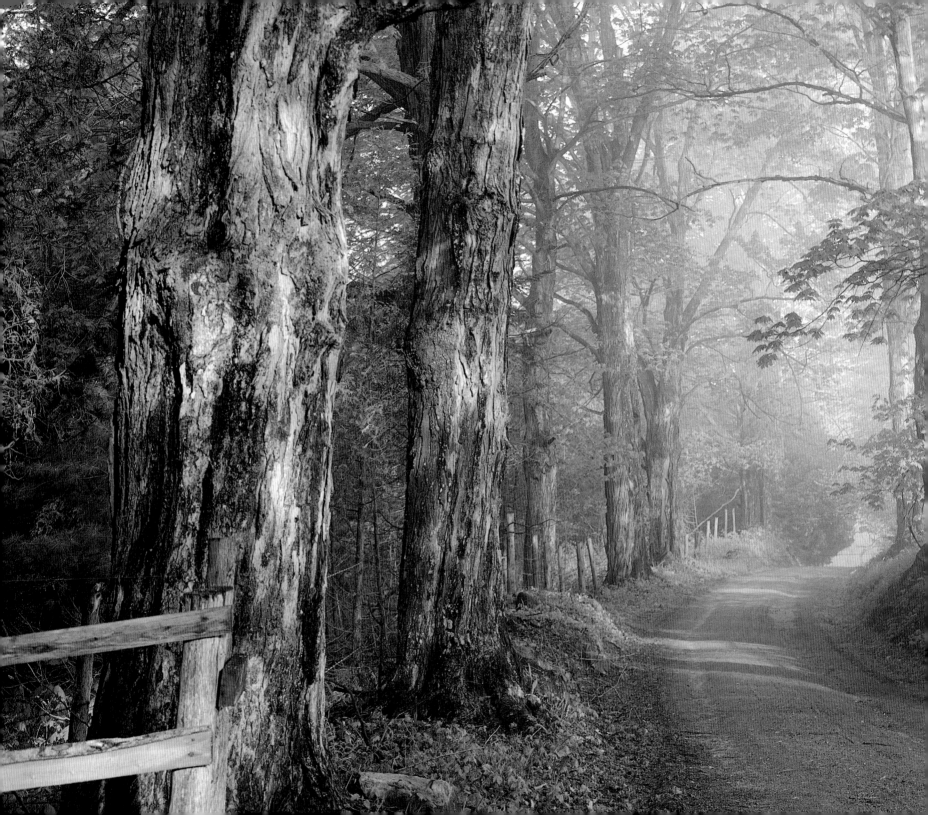

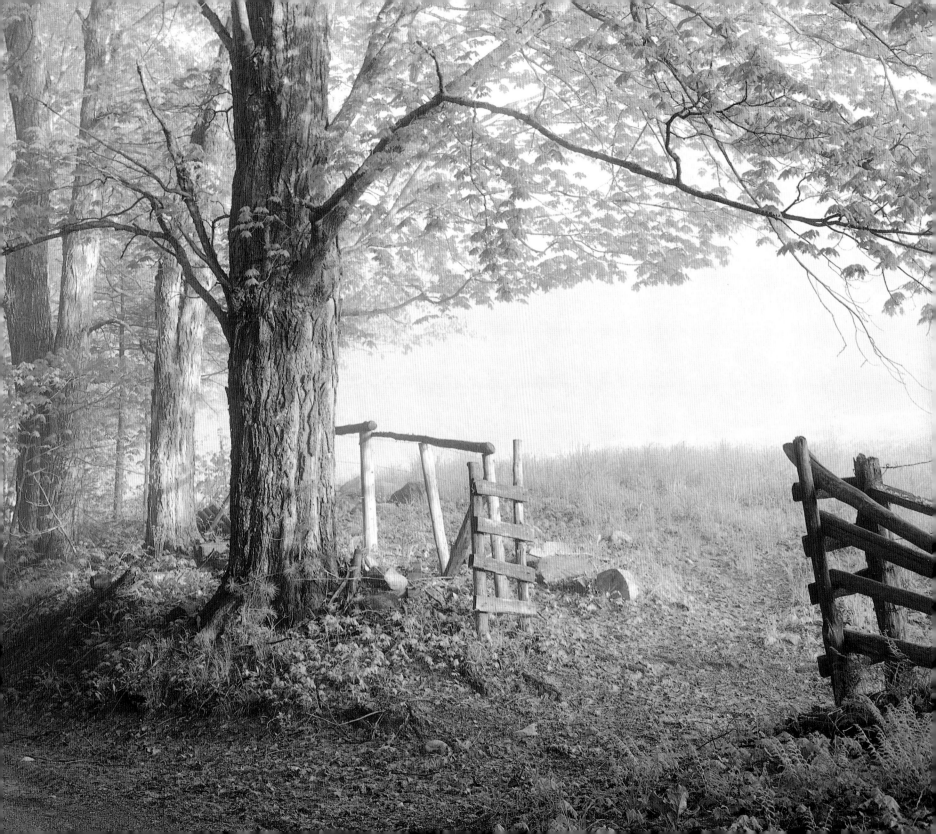

Right:

Planting Peas

NORTHEAST
KINGDOM

Opposite:

Kempton Farm

PEACHAM

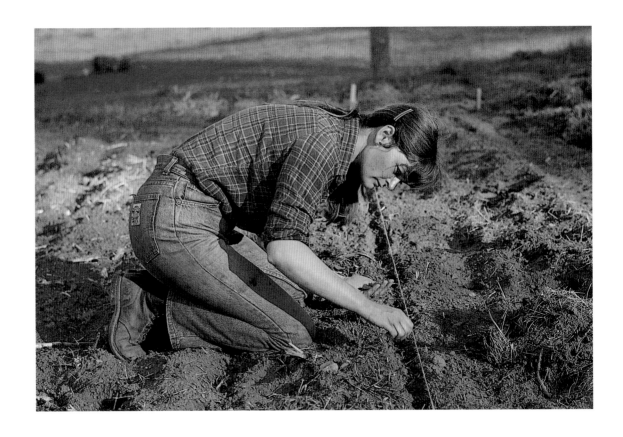

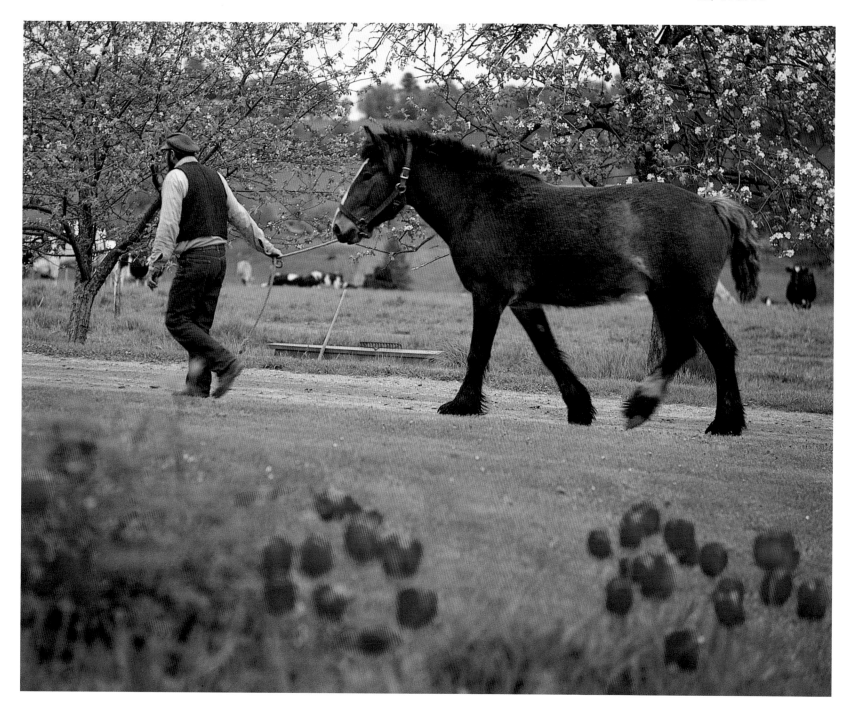

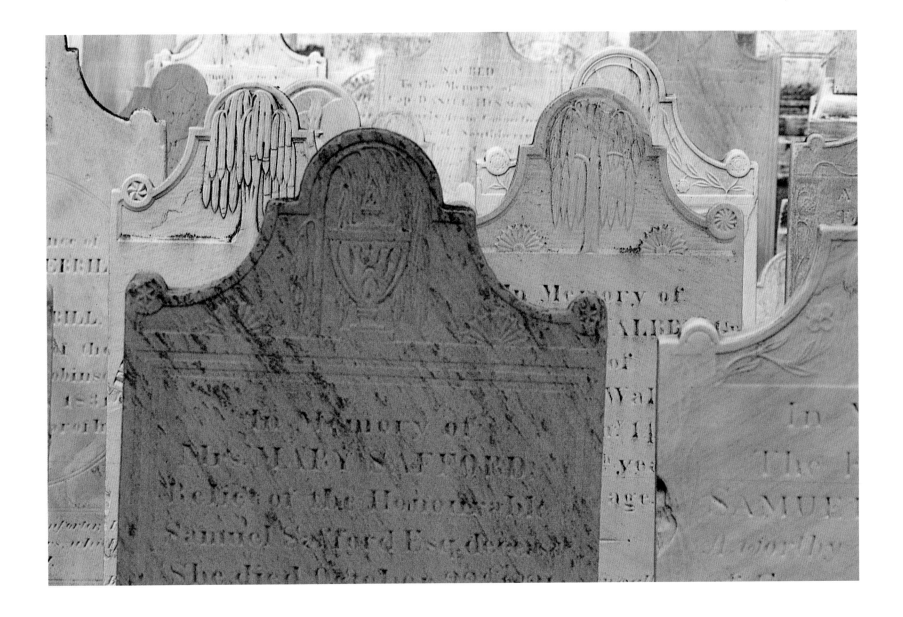

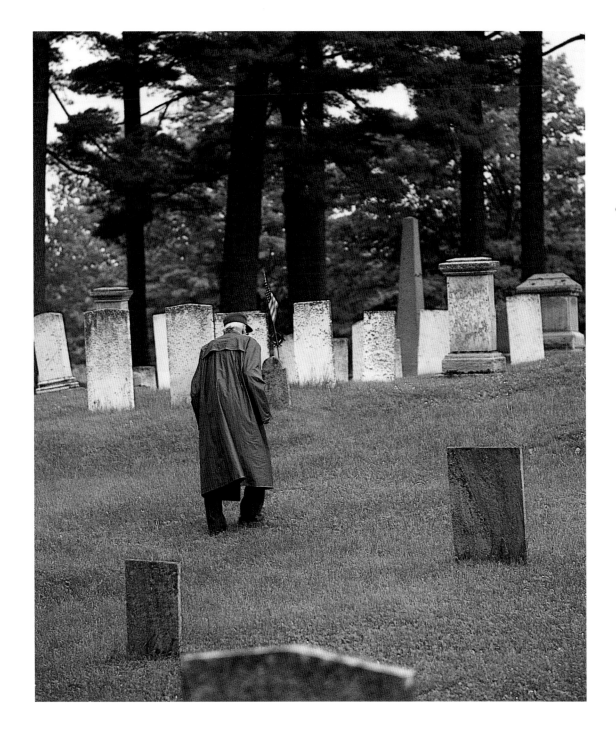

Opposite:

Old First Church Cemetery

BENNINGTON

Left:

Memorial Day

PEACHAM

Right:

Sheep Shearer

N E W B U R Y

Opposite:

Tending the Flock

E A S T P E A C H A M

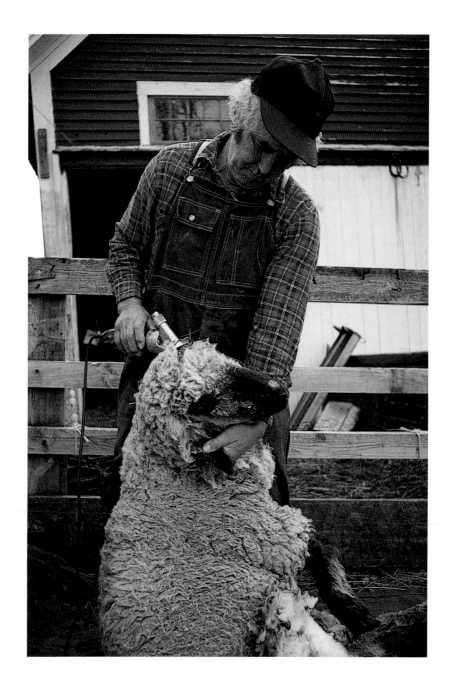

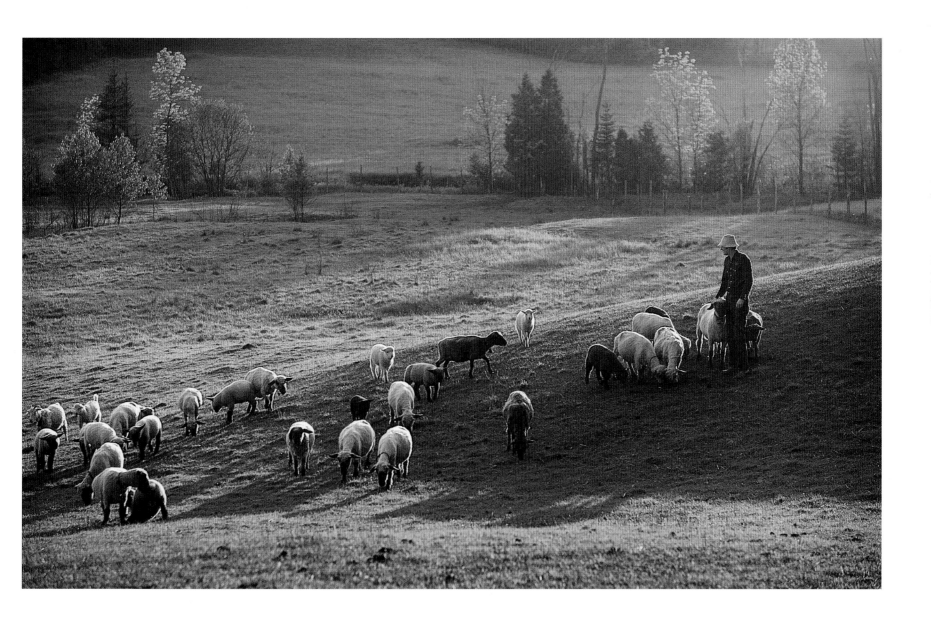

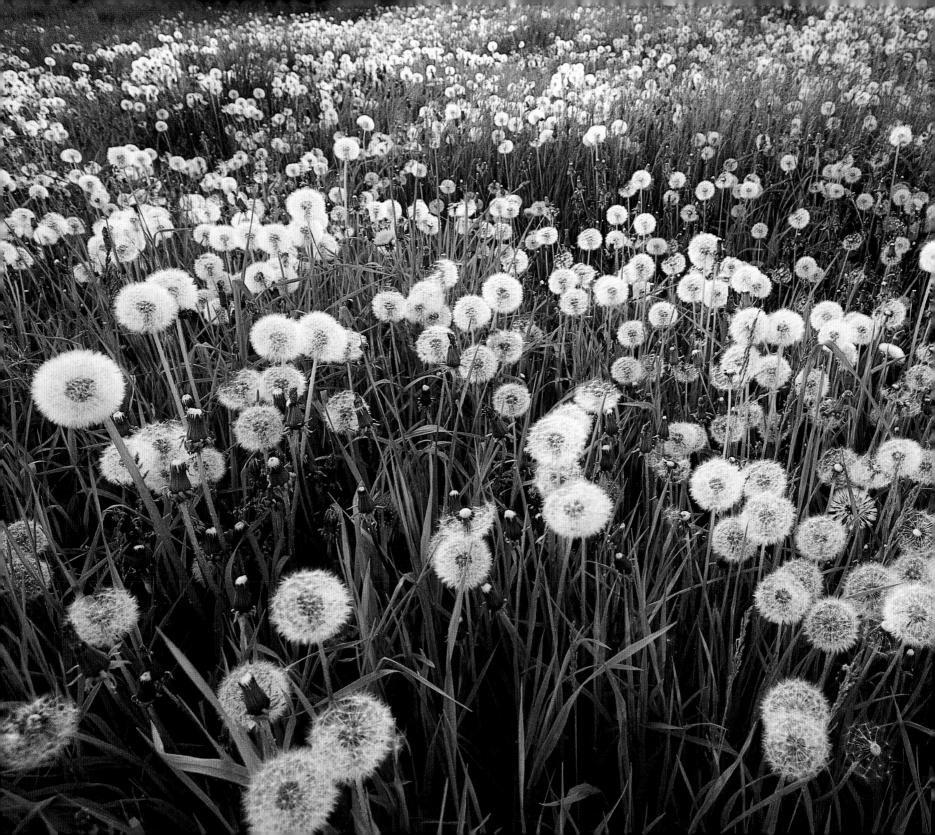

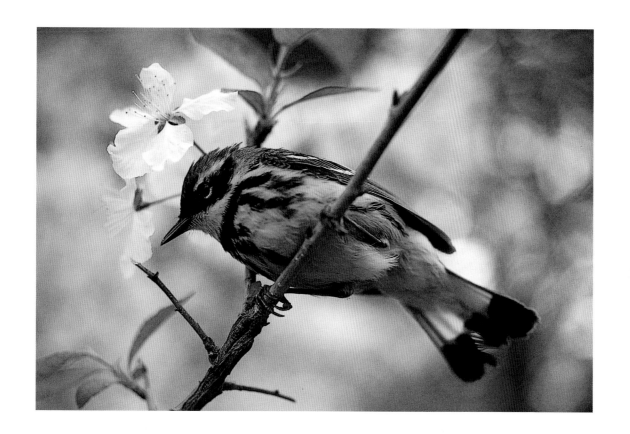

Opposite:
Dandelion Field

PITTSFORD

Left:
Magnolia Warbler

MONTGOMERY

Right:
Nikki and Lilacs

FERRISBURG

Opposite:
Goat and Kids

CALEDONIA
COUNTY

Overleaf, left:
Churchill's Farm

PEACHAM

Overleaf, right:
In the Orchard

POMFRET

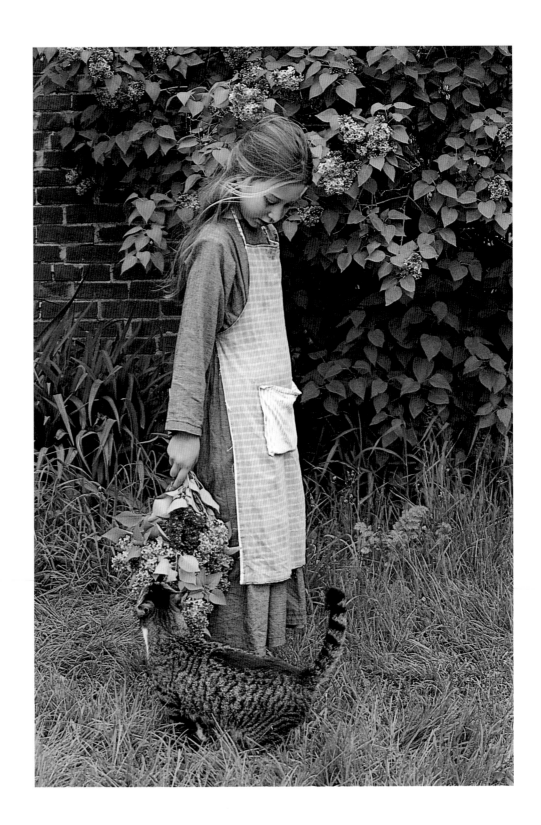

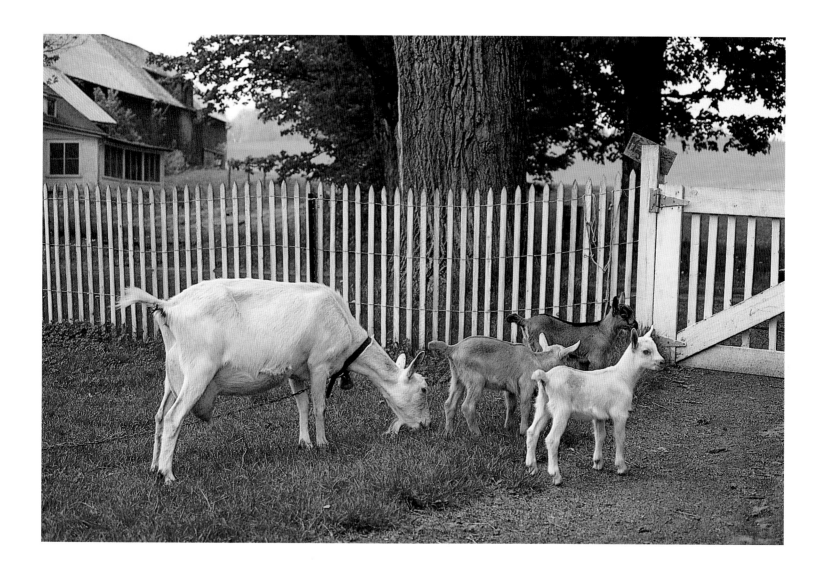

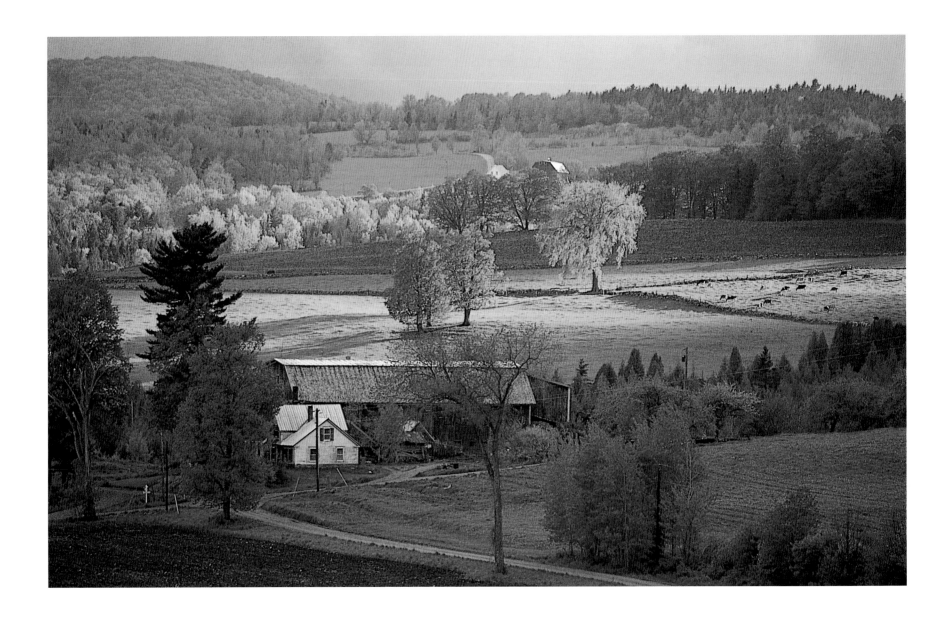

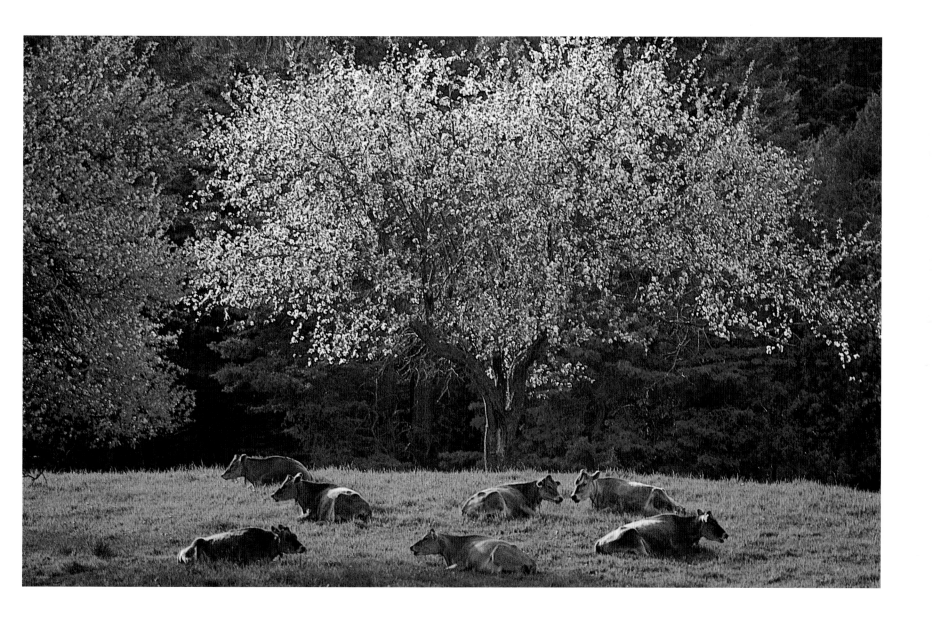

The HEAT *of* SUMMER

VERMONT IN SUMMER IS LUSH AND VERDANT. GEM-LIKE DAYS of cloud-dotted azure skies alternate with enough episodes of wet weather to keep Vermont true to her name. But every year there are two or three spells of truly stifling heat, when the dirt roads bake in the sun and grow thick with dust, when the leaves droop limply from the trees and the rushing waters of spring slow to a trickle.

By nine o'clock on these oppressive mornings, the cows have already abandoned the pasture, seeking refuge in the dark cave of a cellar under the barn or in the blackest part of the spruce woods to escape the searing heat and the deerflies. (These are the ones who seem to always work in pairs: one distracts you by buzzing infuriatingly around your head, while his unnoticed accomplice raises a huge welt on your elbow.) With the heat comes an enervating humidity that makes every movement a major effort.

Only darkness brings relief, for sweltering nights are rare in Vermont. The sun sets like a blood-red ball, the leaves stir, and the cows reappear. But while bearable, a July night can still seem positively equatorial with its jungle rustlings and sounds of strange

wings beating in the dark. Wild animal noises abound: black-crowned night herons screech, bobcats scream, coyotes howl, and foxes bark their high-pitched yelp. Over the swampy places, fireflies form ever-changing constellations while heat lightning flickers nervously on the horizon.

My impressions of summer in Vermont, not to mention a lot of other things about the state, were indelibly formed when I spent a summer off from college, working on a farm a little north of White River Junction. Most of my work revolved around getting the hay crop in, and it was tedious and exhausting work. At that time all hay was put up in rectangular bales wrapped with two strands of baling twine that cut into the insides of your fingers every time you lifted a bale. Until your hands toughened up they were a sorry mess. Inside the barn it was about 110 degrees, and as you unloaded the hay from the wagon up into the sweltering loft, the barn swallows would attack with swoops and dives and calls of alarm.

The middle-aged couple who owned the place were quintessential fifth-generation Vermonters. He was rail thin, lantern-jawed, and always wore faded bib overalls. She was plump and red-cheeked and always dressed in a loose-fitting cotton house dress. Every day at noon she would give the farm bell rope a couple of yanks and the

"men," namely myself and a couple of other "dumb college kids," would cheer, head for the house, and wash up. I think we all realized her midday meals were a rare experience, and God knows we were hungry. These were gargantuan, sit-down, meat and potatoes, Sunday dinner type meals with some unbelievable cake or pie for dessert. How well I remember that dining room—always cool, even in summer's heat—a room with a lot of dark wood in it, and white doilies, and heavily framed photographs of ancient relatives scowling down at us.

After the meal was over, if it was one of those blistering hot afternoons, the farmer would let us off for a couple of hours. We piled into the farm truck and drove down to the green iron bridge that spans the White River at West Hartford. Climbing to its uppermost girder, we paused to summon our courage (and to catch the attention of any girls that might be sunning themselves on the rocks far below). Then, with the requisite yell, we leaped out into the void. Our lives flashed before us. A surprising amount of time passed. Then came a tremendous smack and instant immersion in a deliciously cool, wet, and dark world. The water's shattered surface sparkled reassuringly overhead, and while coming up for air we wondered if we were still hot enough, brave enough, or dumb enough to try it again.

Right:

At the Trough

CABOT

Opposite:

Quitting Time

WASHINGTON
COUNTY

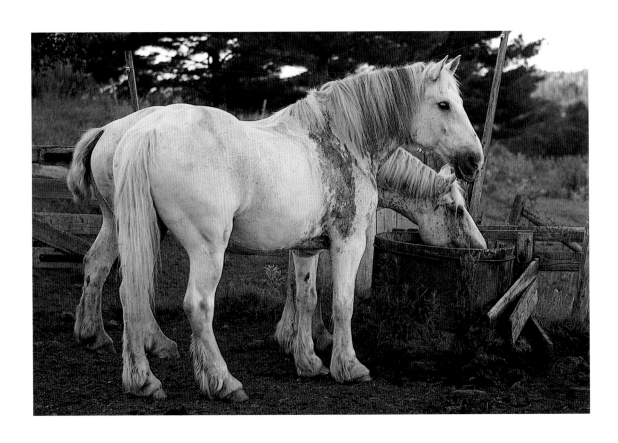

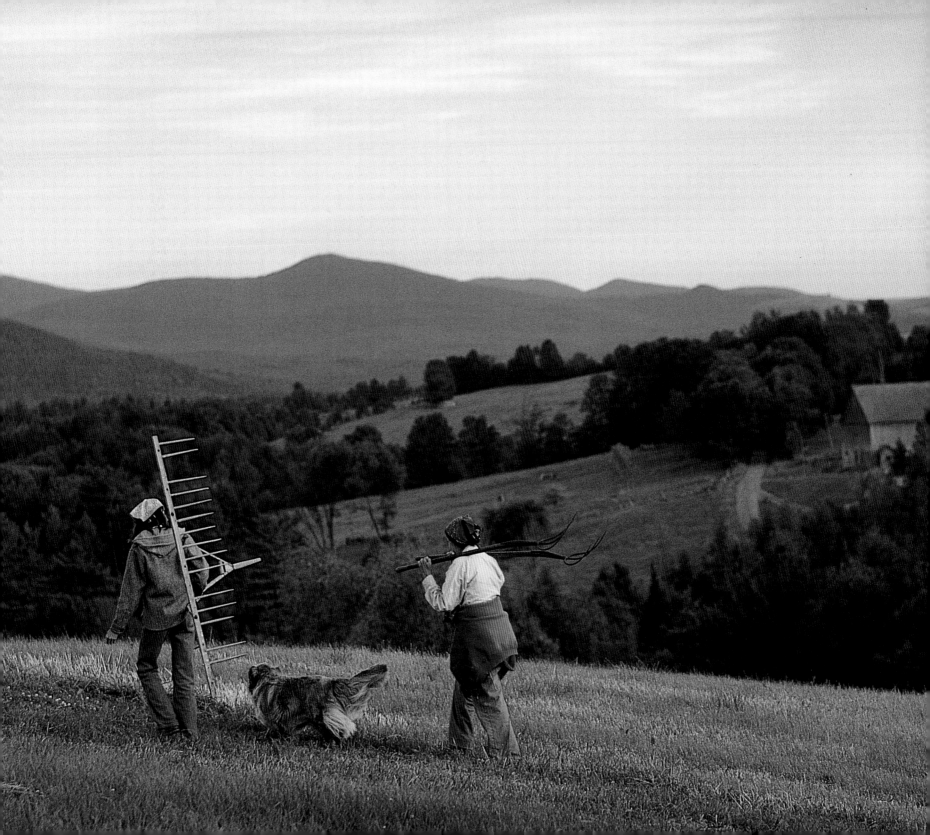

June Wildflowers

JEFFERSONVILLE

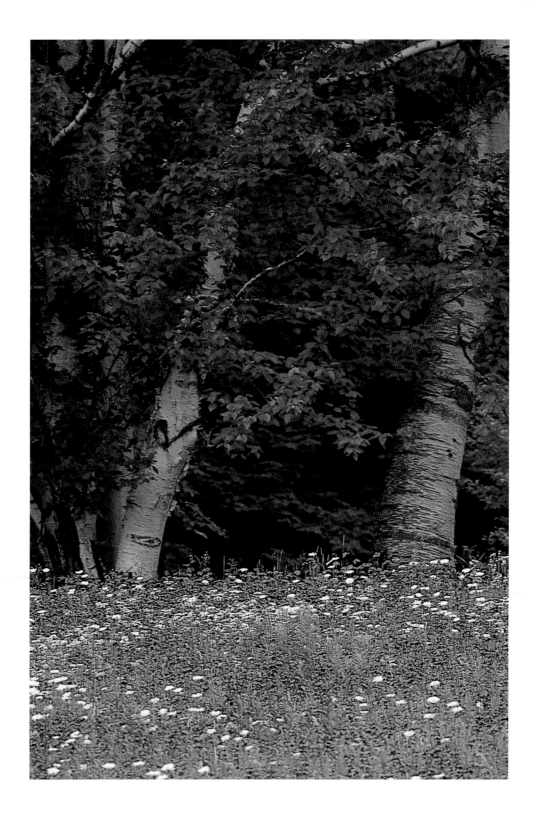

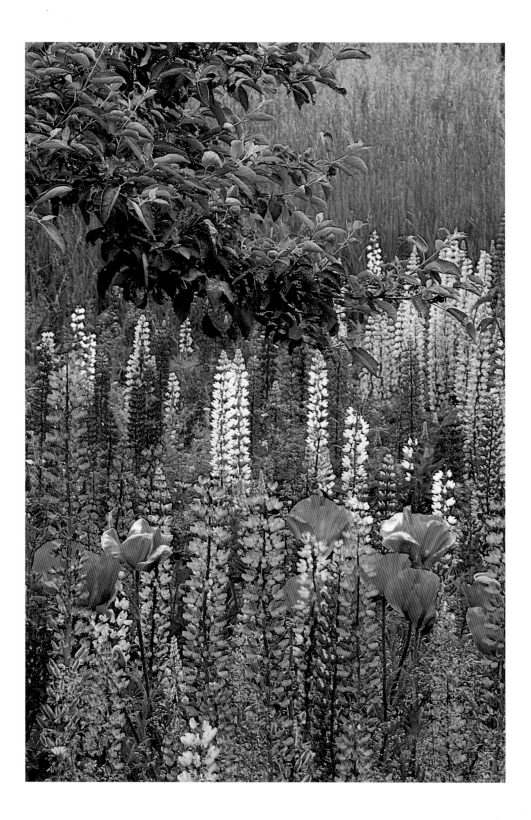

Lupines and Poppies
———
EAST
MONTPELIER

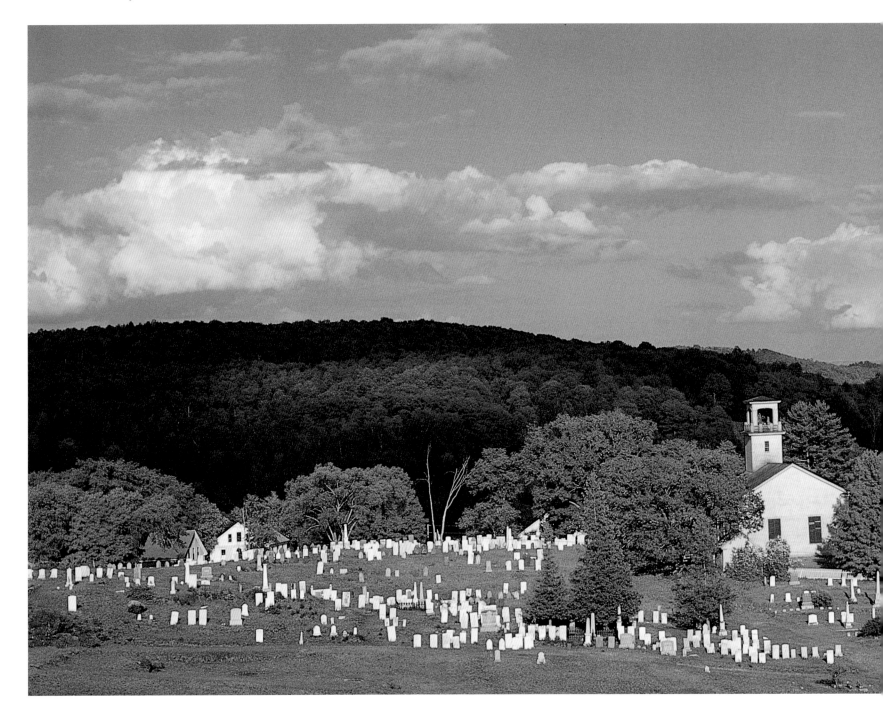

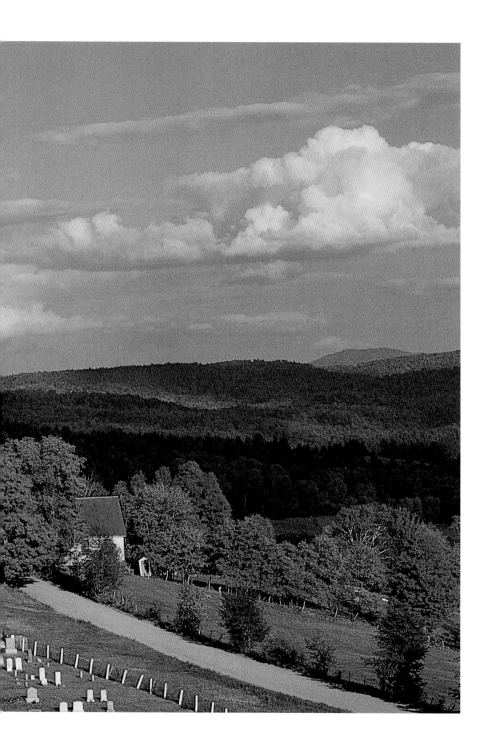

Cloud Shadow

CORINTH
CENTER

Overleaf, left:
Birch and Iris

PEACHAM

Overleaf, right:
Sadawga Pond

WHITINGHAM

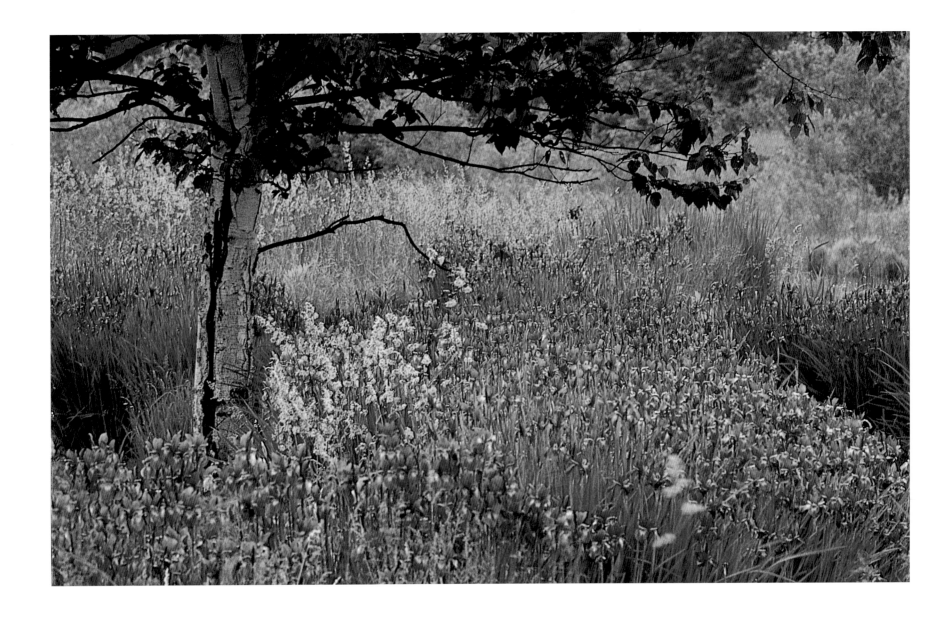

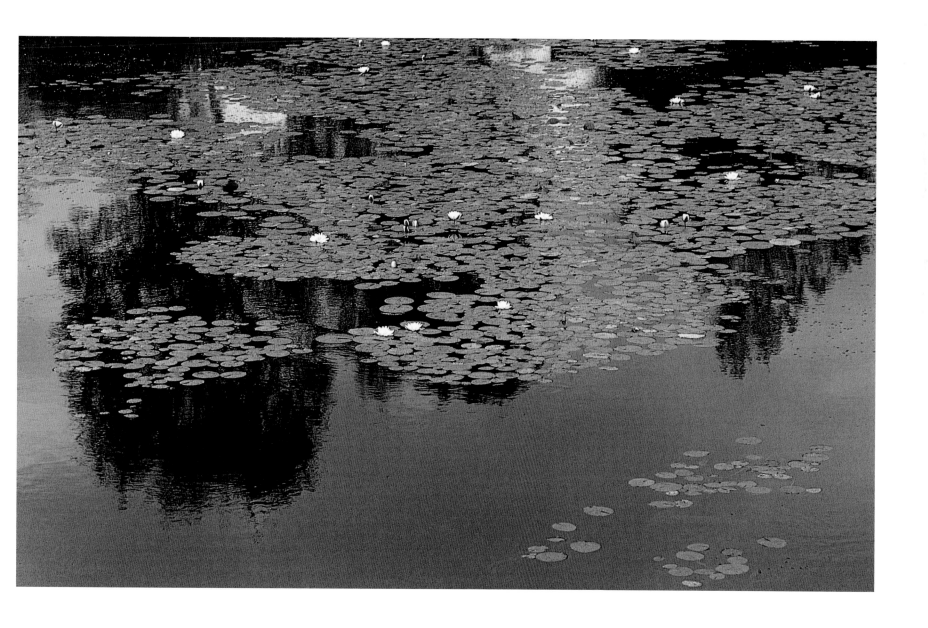

Right:
Gretchen's Garden

PEACHAM

Opposite:
Ida's Garden

GLOVER

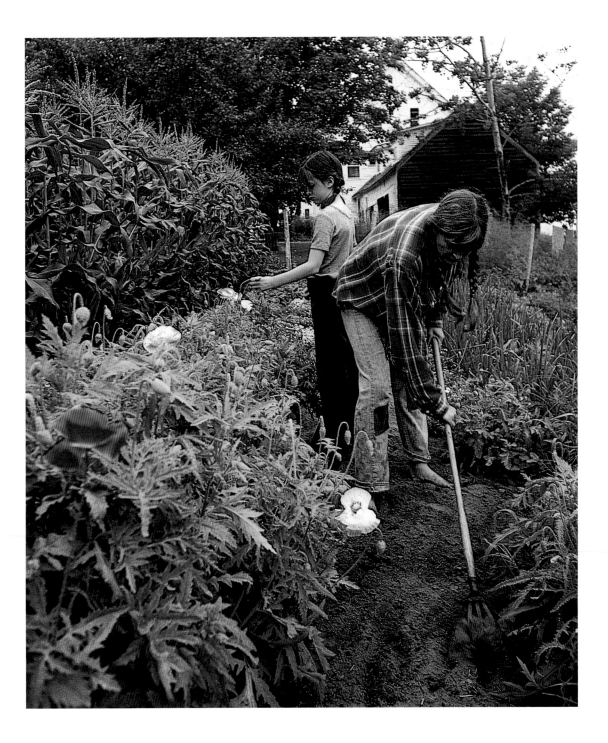

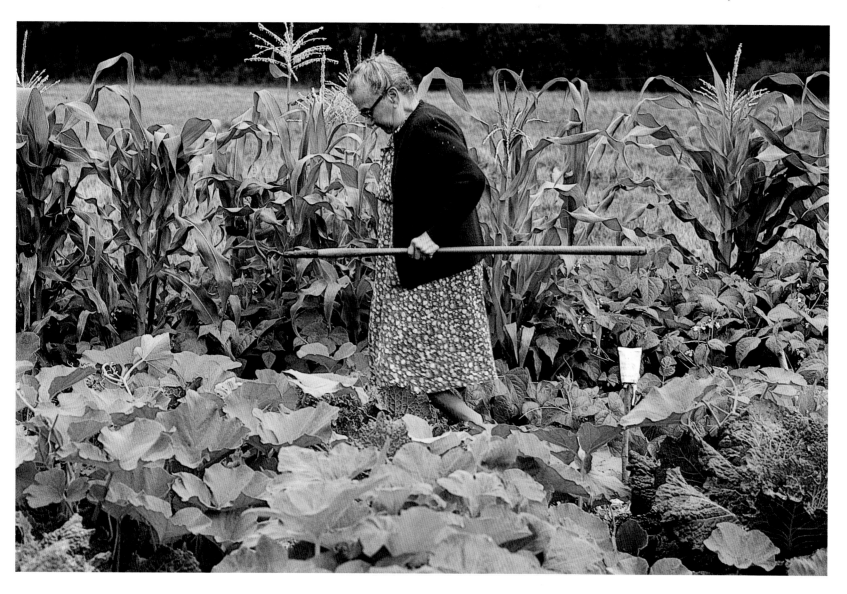

Right:
Full Moon

W E S T B A R N E T

Opposite:
Graveyard Fence

P E A C H A M

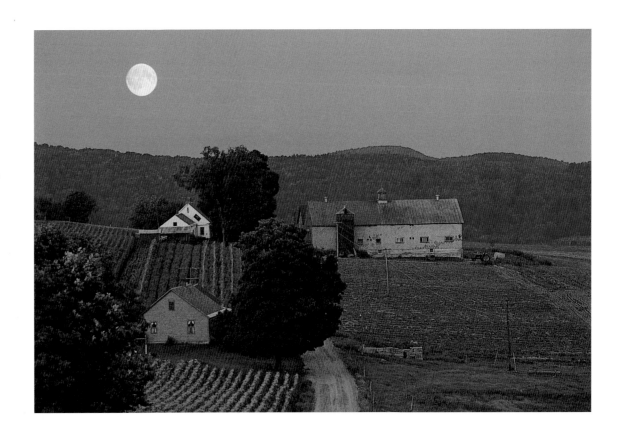

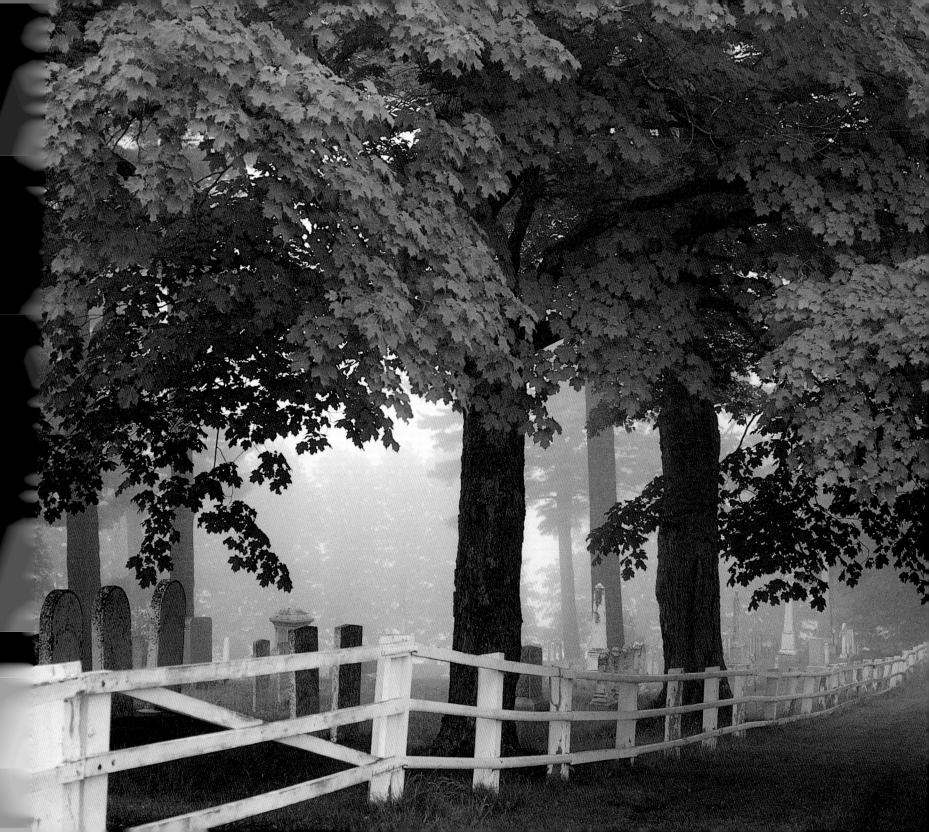

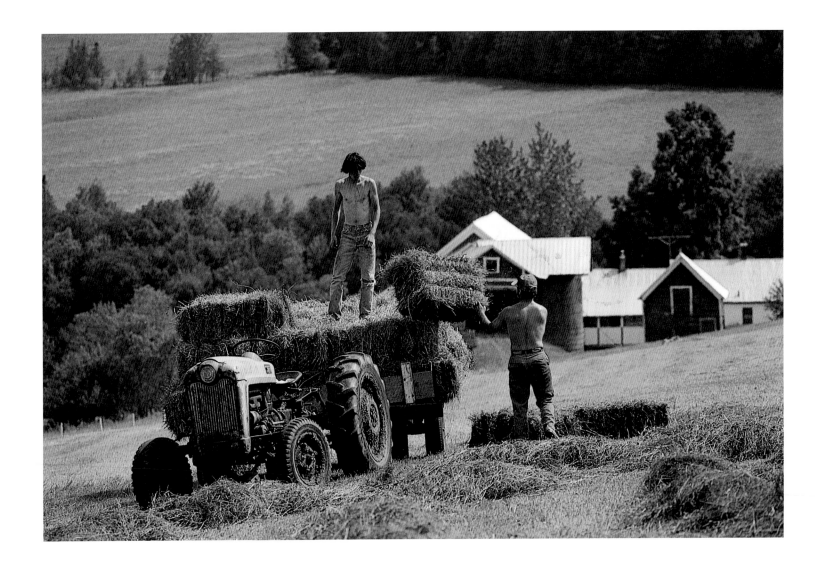

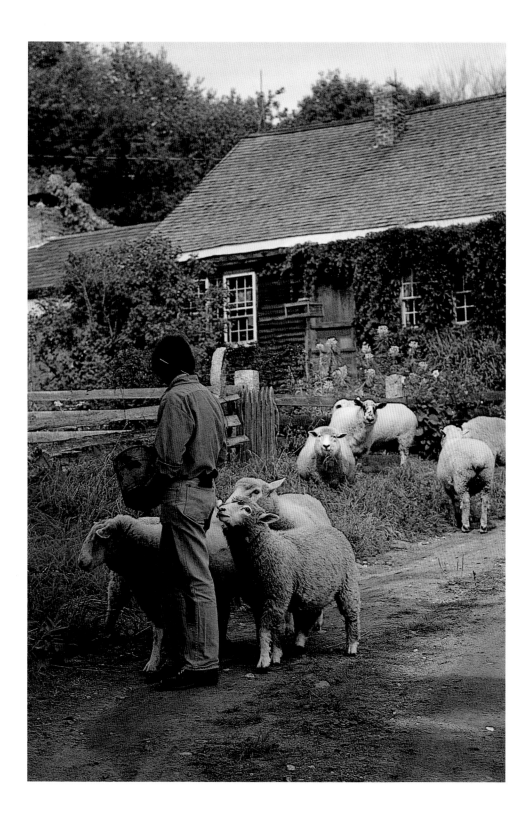

Opposite:

Haying

DANVILLE

Left:

Cottage Garden

CABOT

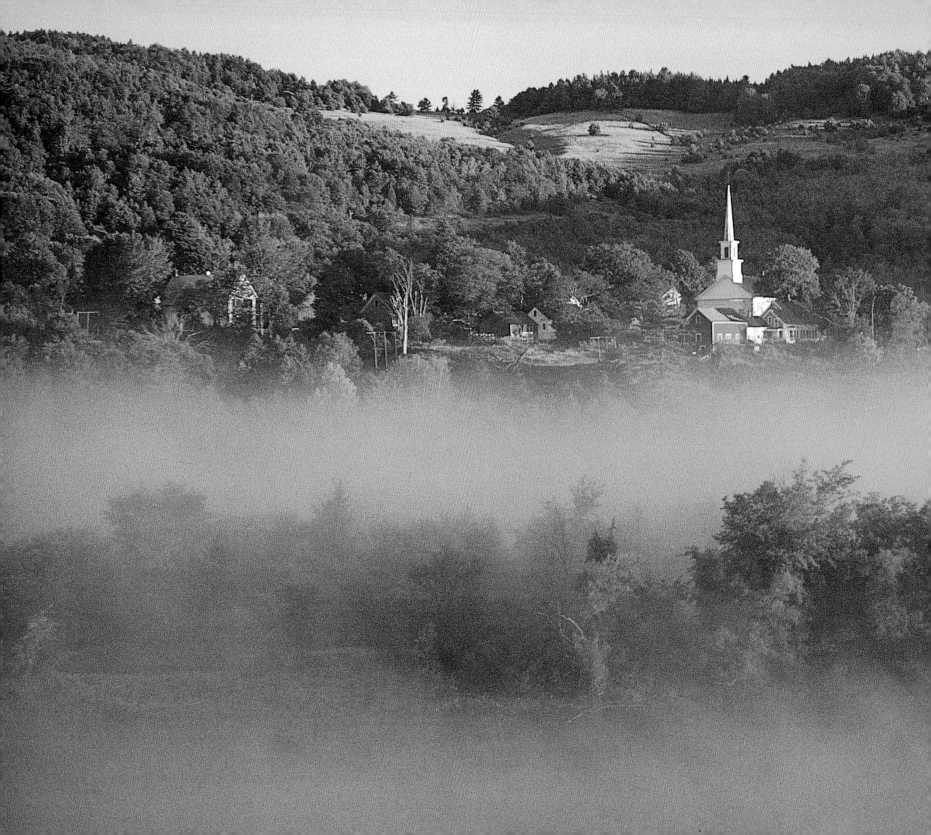

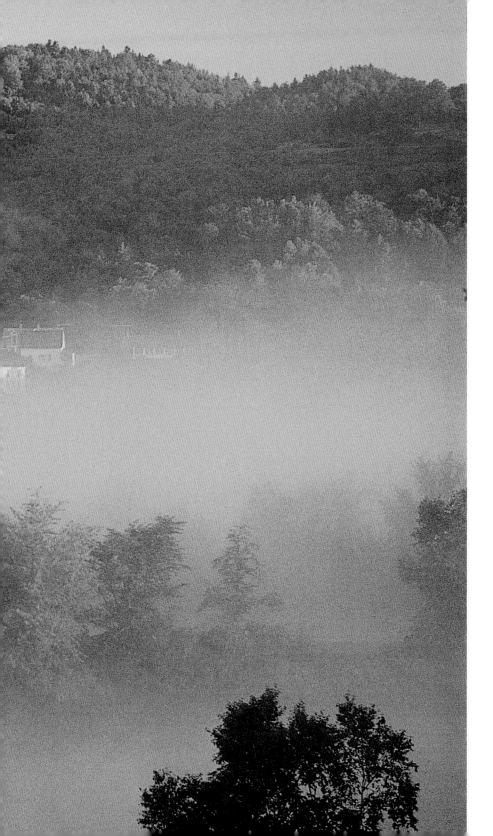

Connecticut River Fog

———

BARNET

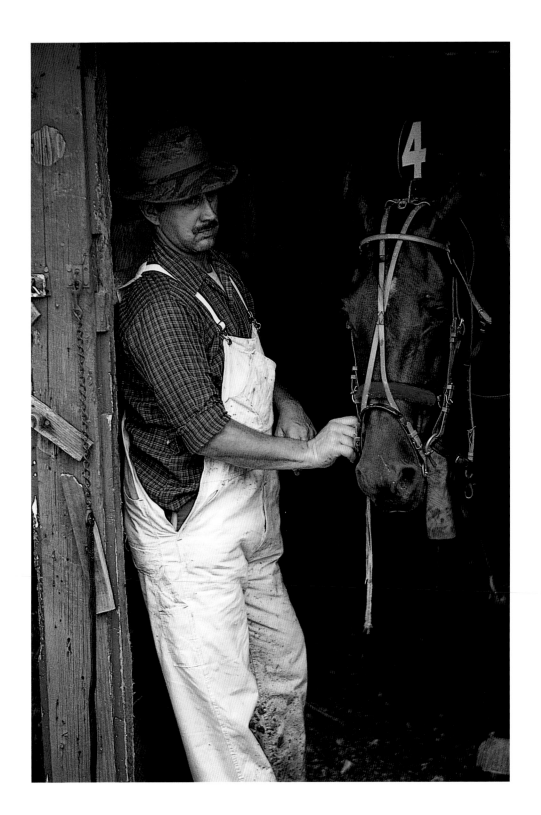

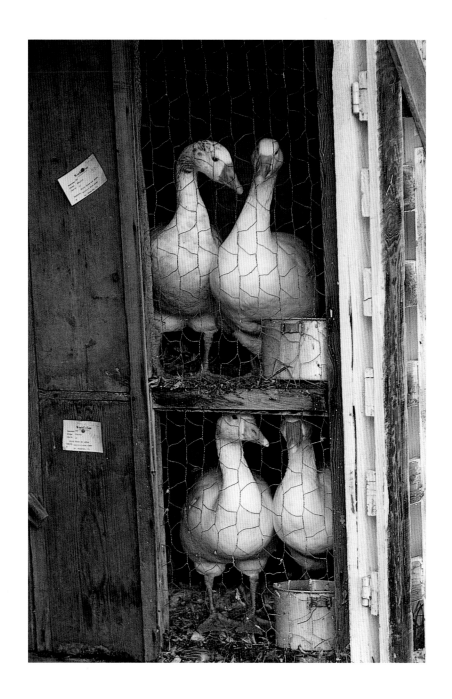

Opposite and left:
Tunbridge World's Fair
———
TUNBRIDGE

Right:
Prize-winning Chicken

TUNBRIDGE

Opposite:
Horse Pulling

DANVILLE

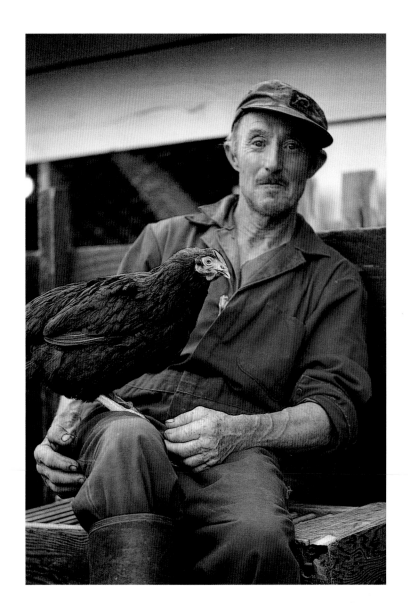

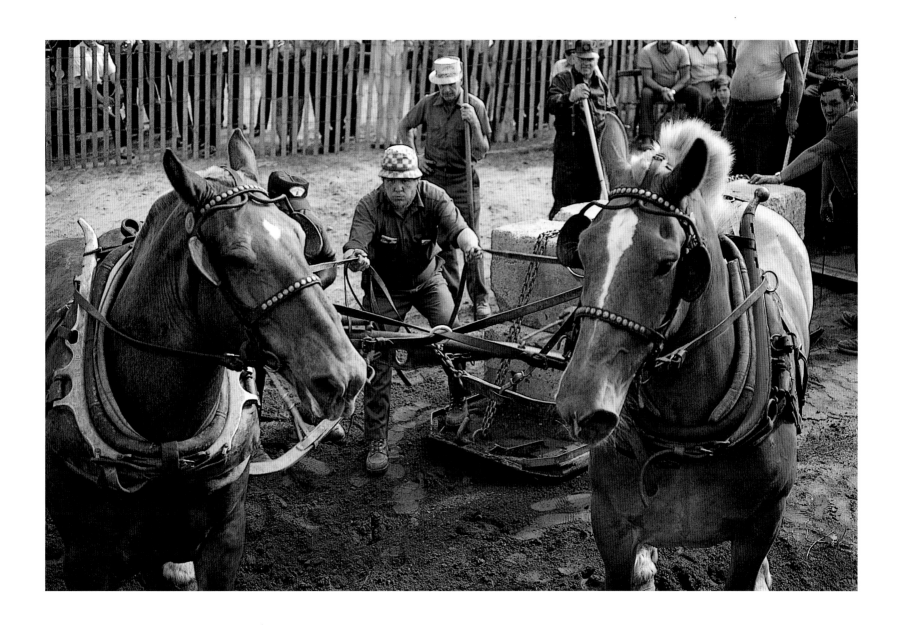

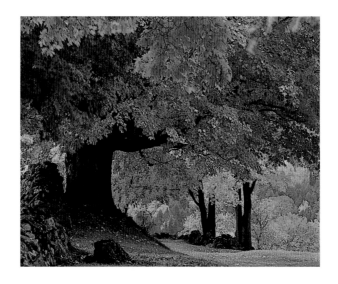

F R O S T *and* F O L I A G E

Autumn is Vermont's most evocative season. Days are suffused with the warm glow of the turning trees. Morning fog and autumn haze and the remembrance of burning leaves all contribute to an oddly pleasant melancholy unique to this time of year. It is a season that plays on our memory, that touches our collective past; a season of reminiscence, but not regret.

The air is filled with the fragrance of damp fallen leaves and frost-bitten ferns, occasionally punctuated by the sharper smell of wood smoke curling from farmhouse chimneys or the pungent tang of manure spread on corn stubble. Chill, silver mornings, when the fields are rimmed with frost, give way to summer-like afternoons. Crickets find their voice again after being numbed by the cold, and monarch butterflies, having hunted in vain for unwithered milkweed, begin their impossible journey to Mexico.

The deer grow bold, searching for fallen apples in the old orchard in front of the house. In the morning I can see their tracks radiating out from each tree, etched in the frost. They are welcome to eat their fill, for the apples have grown dry and wormy with age.

We used to buy good apples from the "apple man" who would appear at the farm every fall. He was a Frenchman from Quebec, fond of telling ribald tales; a short, rotund man, shaped like his fruit, who drove a red van with APPLES painted on one side and POMMES on the other. We always bought a box or two and put them in the cellar, where they spoiled before we could finish them. But they filled the house with their ripe, winey perfume for months.

More welcome visitors, and far more evocative, are the flocks of wild geese that appear overhead as the sumacs and woodbine redden along the back pasture walls. How many autumn evenings have I been cooking supper in the house or stacking wood in the woodshed when I've heard that soul-stirring chorus of distant honking, and rushed outside to see great ragged lines of Canadian geese cresting over the horizon? They use the Connecticut River, which lies some half-dozen miles to the east of our farm, as their navigational beacon. There are certain days in October when the flying conditions must be ideal, or the migratory urge overpowering, for wave after wave pass overhead in great clamorous V's. A few noisy renegades always jockey for position toward the apex of each flock, while a handful of weary stragglers waver at either end.

The geese follow the river as it flows south, passing over Canaan, Lunenburg, and Waterford, then on over Passumpsic and Barnet, searching for the rich river-bottom corn fields at Newbury

and Bradford for a place to settle for the night. As evening falls the flocks come faster and lower, so low I can hear the air whistling through their pinion feathers and the heavy rhythmical beating of their wings rowing in unison through the air. I can even see the fading light glinting off their eyes as they peer down warily in my direction.

I know exactly what these eyes see, having flown a small plane over this same autumnal landscape at just this hour and just this height. I know they look down on neatly mowed hayfields and scraggly overgrown pastures and hardwood stands of maple and ash smoldering among the darker evergreens. Where the river turns briefly westward at Gilman, they see it flash rose-orange under the setting sun, and as dusk gathers they see wisps of ground fog form like cotton batting over the lowlands and lights blink on in the miniature farmhouses and villages strung haphazardly along the riverbanks below.

I suppose these geese are untouched by the magic of this perspective and the beauty of Vermont's multi-hued hillsides flowing by beneath them. No doubt they are also oblivious to their innate gift of flight. It is, after all, as automatic and mundane to them as breathing. But they are all the more moving to us because of their unwitting wildness, sounding their primordial evening angelus, calling us to pause and wonder at the autumn spectacle that surrounds us, and give thanks.

Richmond Brook

———

BARNARD

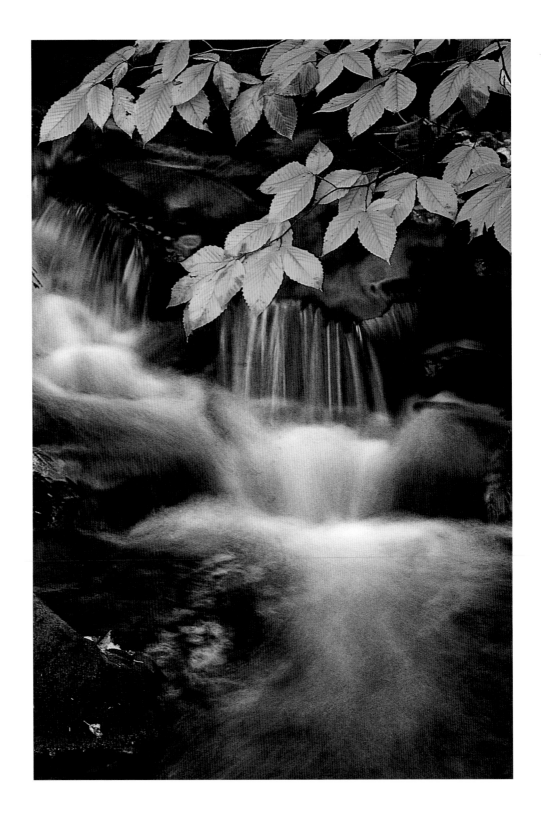

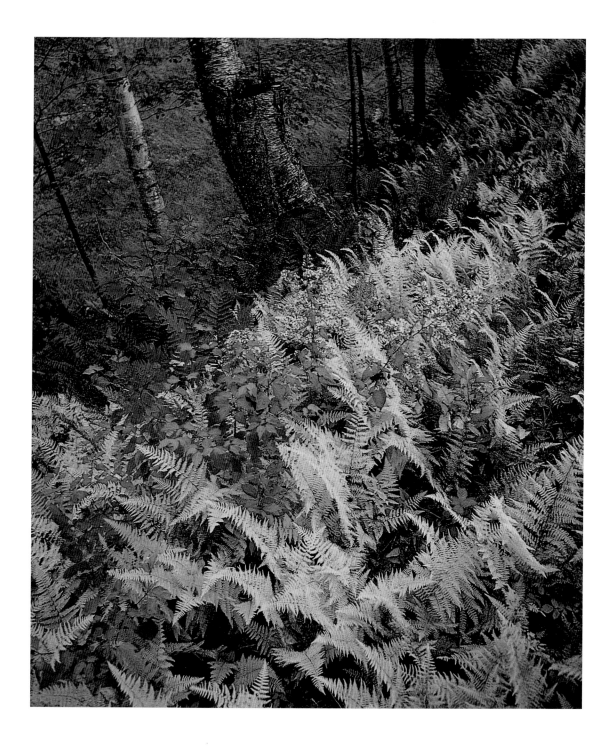

Hay-scented Ferns

CRAFTSBURY

Right:
Basket of Apples

P E A C H A M

Opposite:
Front Porch

W A I T S F I E L D

Overleaf:
Dawn

N O R T H E A S T
K I N G D O M

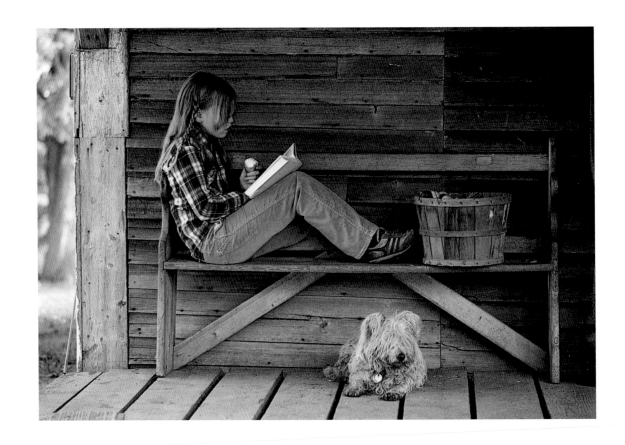

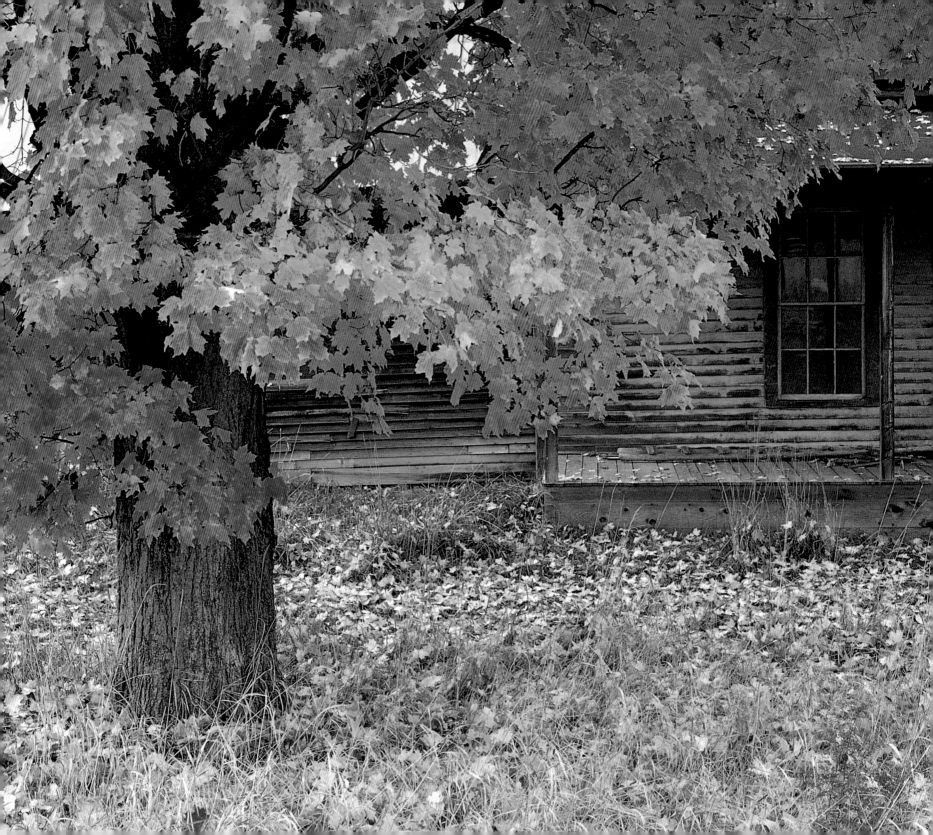

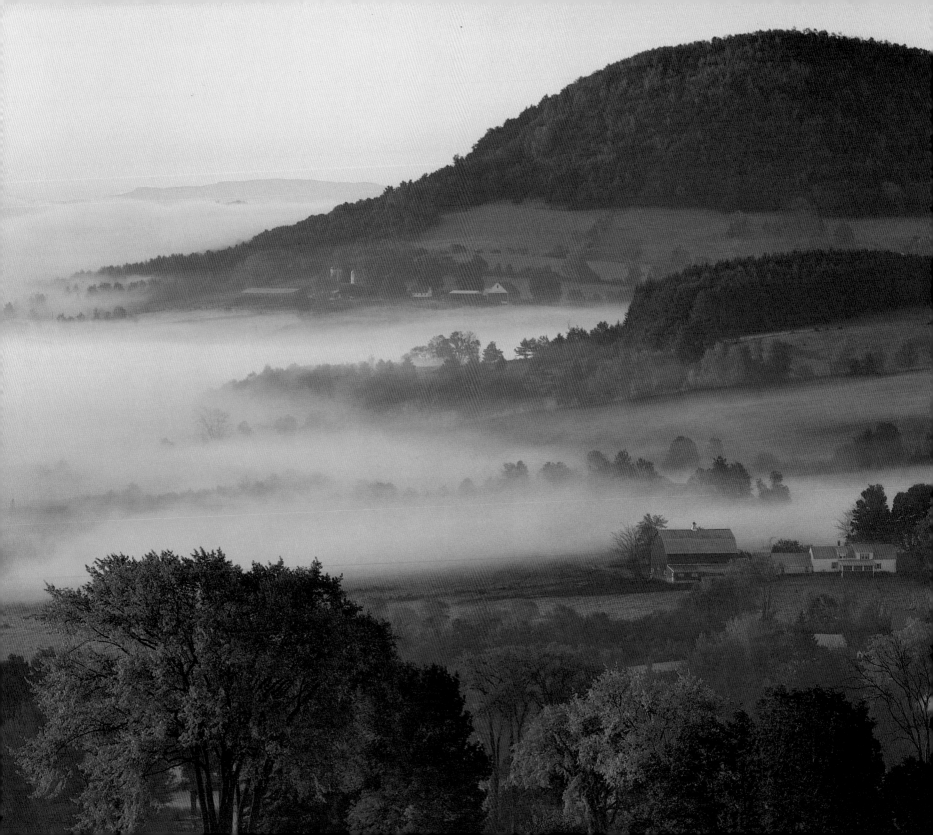

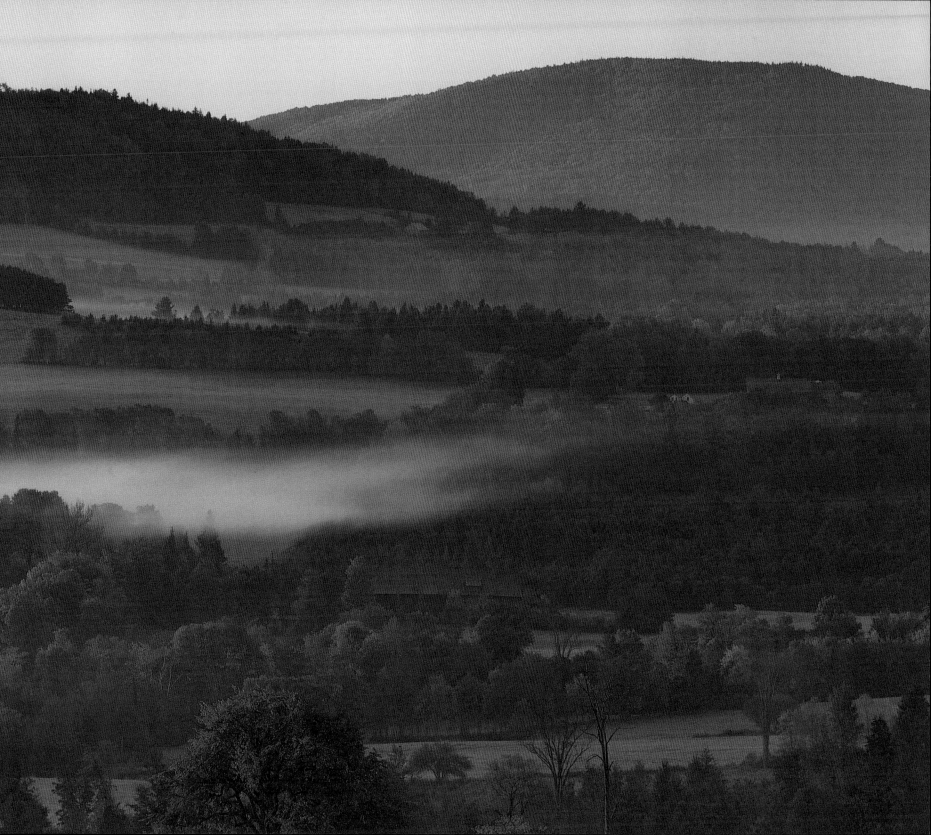

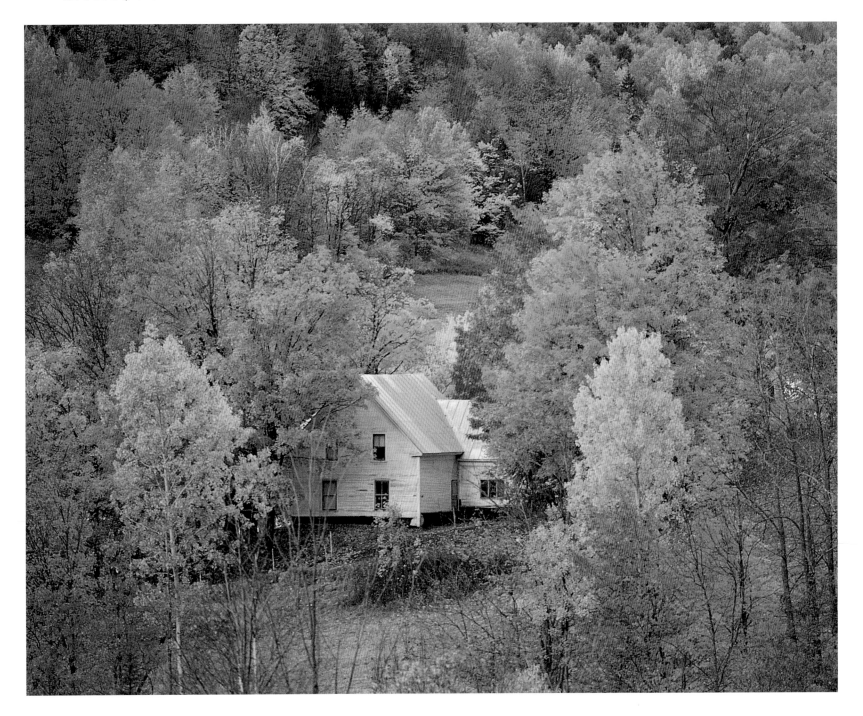

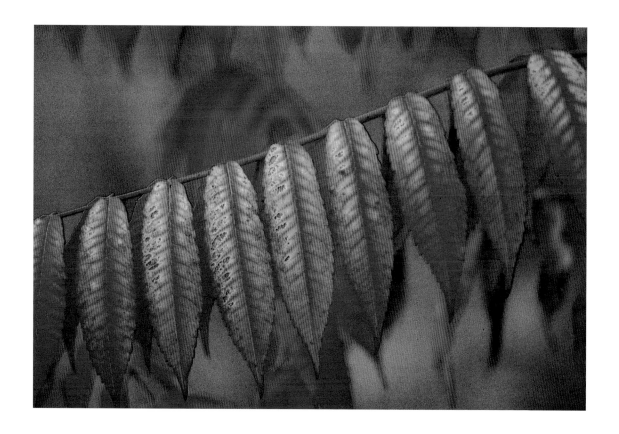

Opposite:
Autumn Colors

E A S T O R A N G E

Left:
Sumac

S H E L B U R N E

Right:

Runaway Pig

WEST BARNET

Opposite:

Last Hay Crop

CALEDONIA
COUNTY

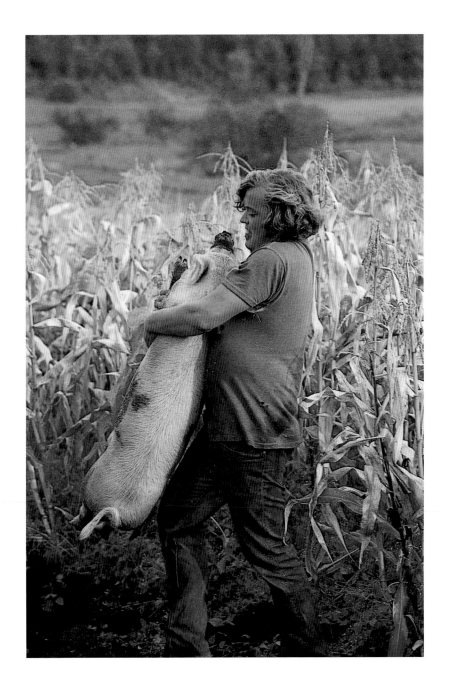

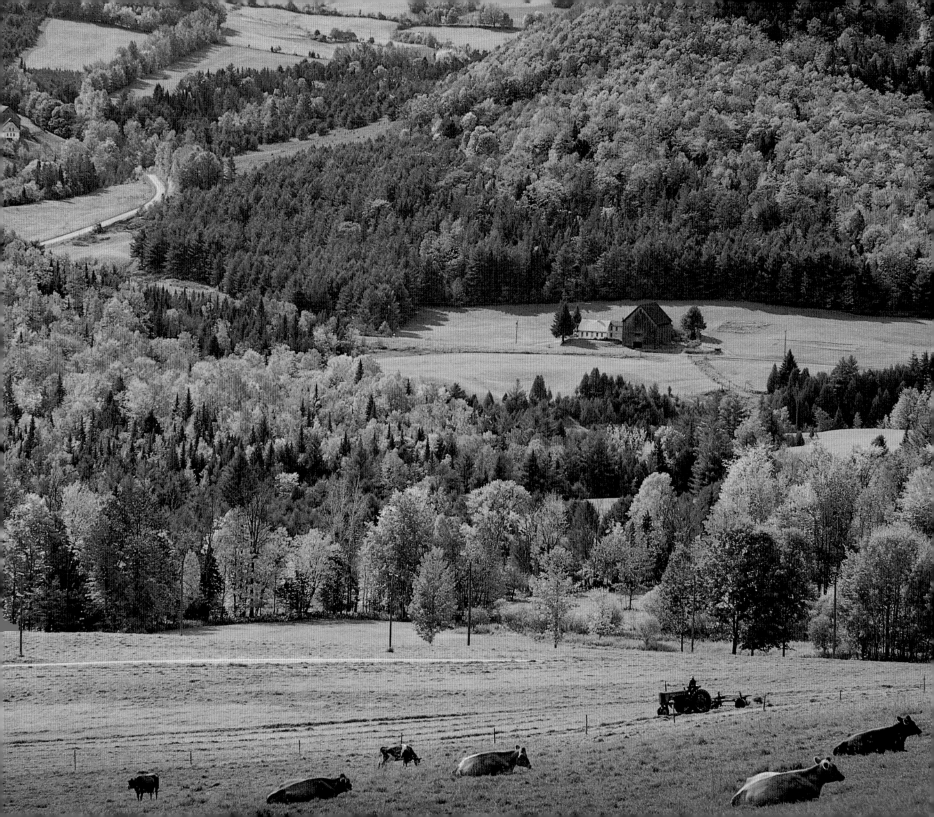

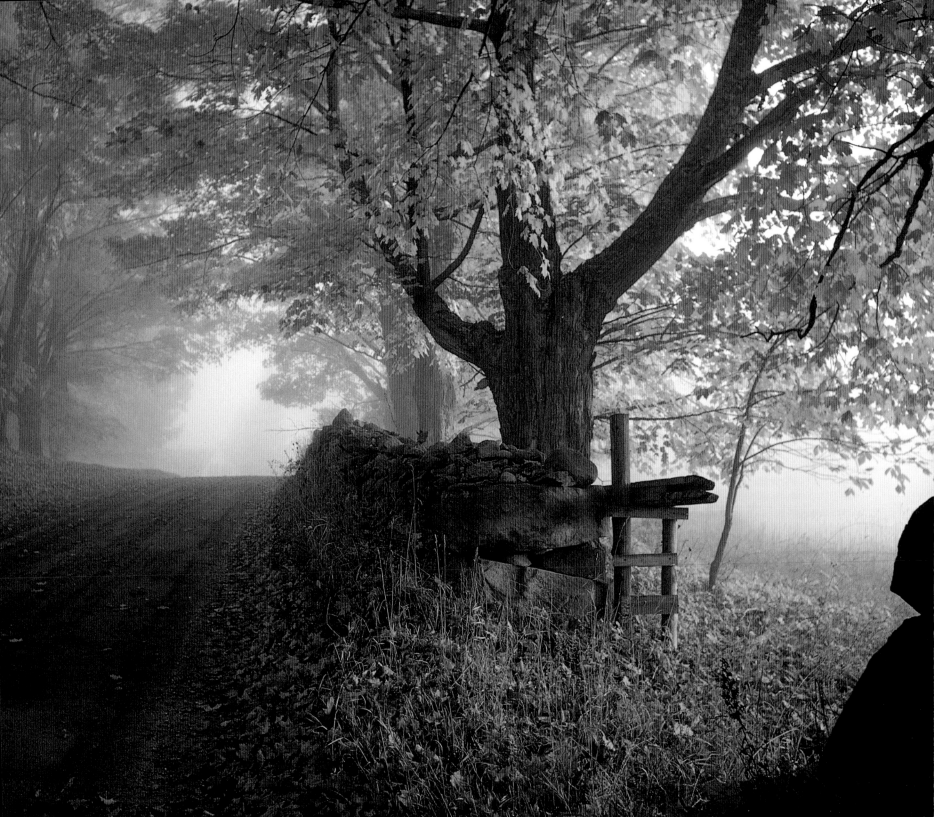

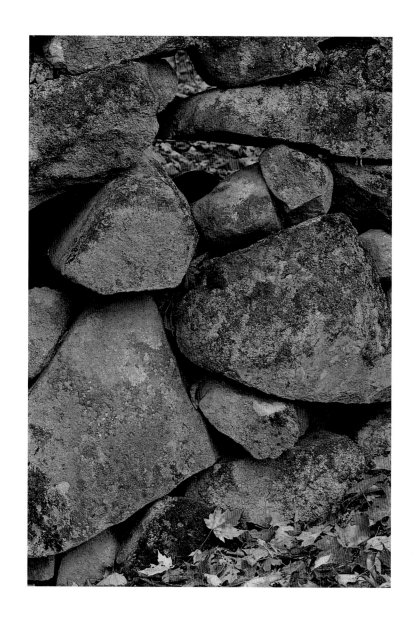

Stone Wall and Barway

Mosquitoville

Left:
Granite Wall Detail

Bethel

Overleaf, left:
Reflection, Hidden Lake

Marlboro

Overleaf, right:
Deerfield River

Readsboro

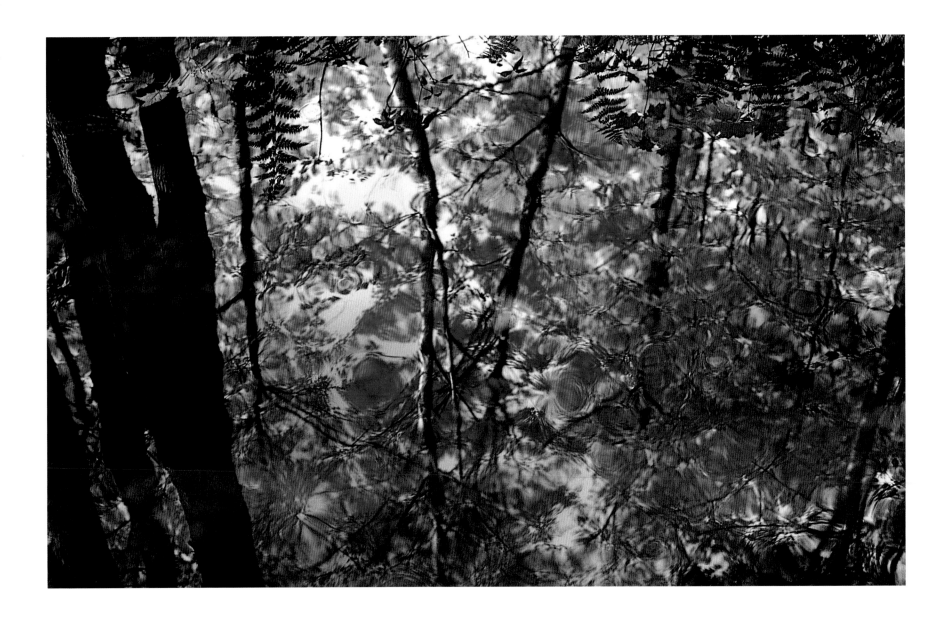

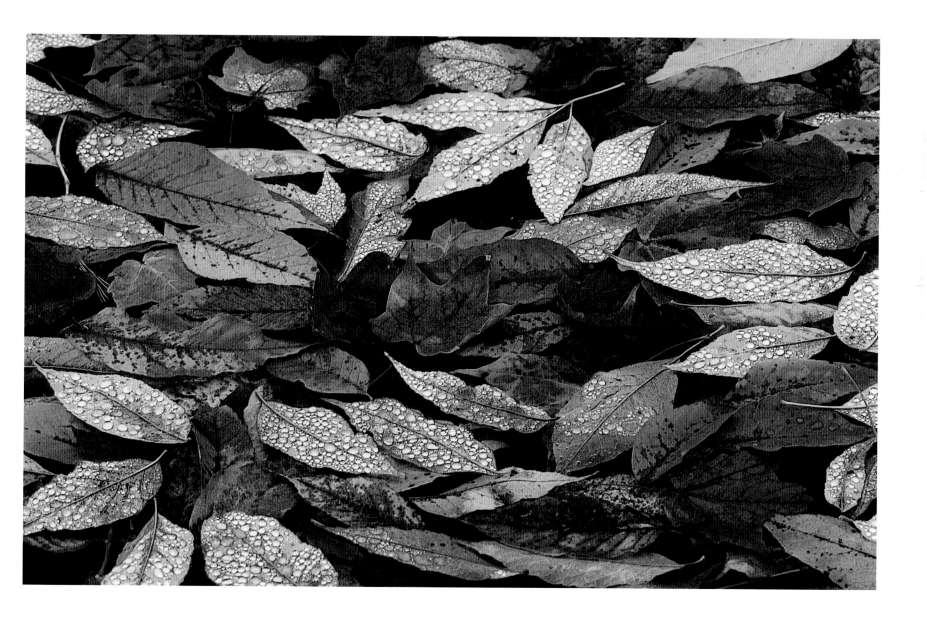

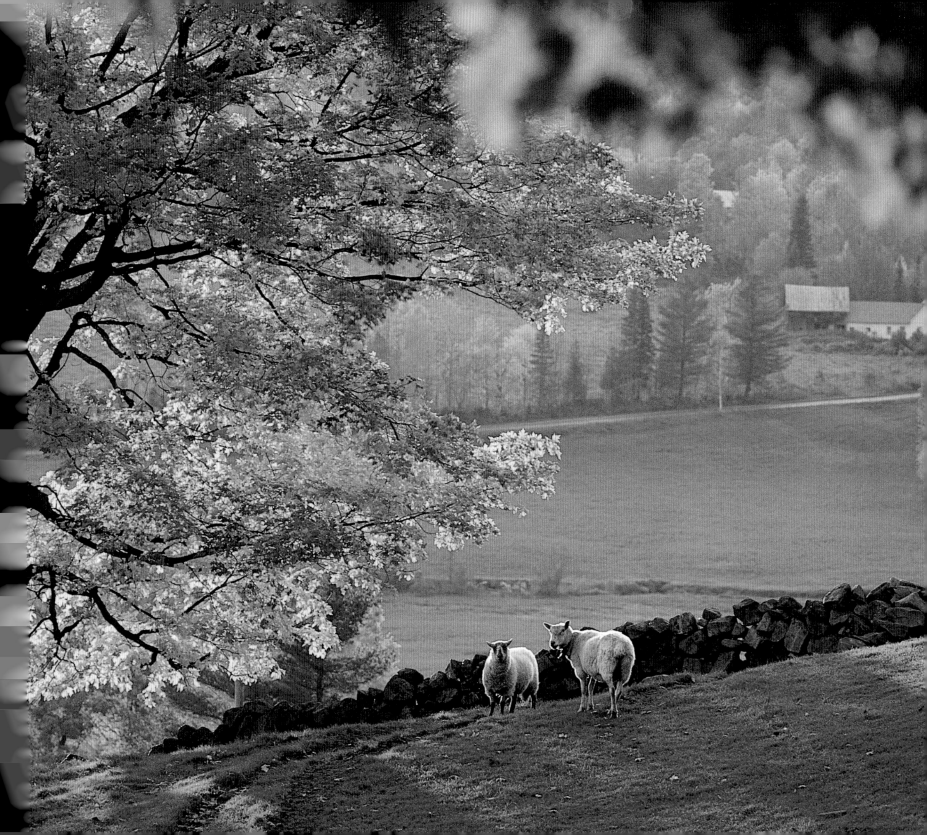

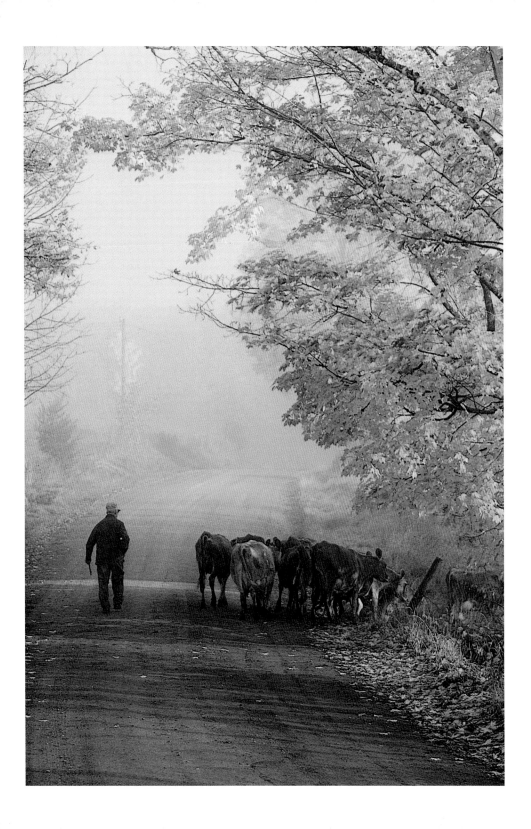

Opposite:

Morrison's Sheep

WEST BARNET

Left:

Out to Pasture

EAST PEACHAM

Right:
Jack-o-Lanterns

WELLS

Opposite:
Raking Leaves

WEST BARNET

Overleaf, left:
Molly's Falls Pond

MARSHFIELD

Overleaf, right:
Gillett Pond

RICHMOND

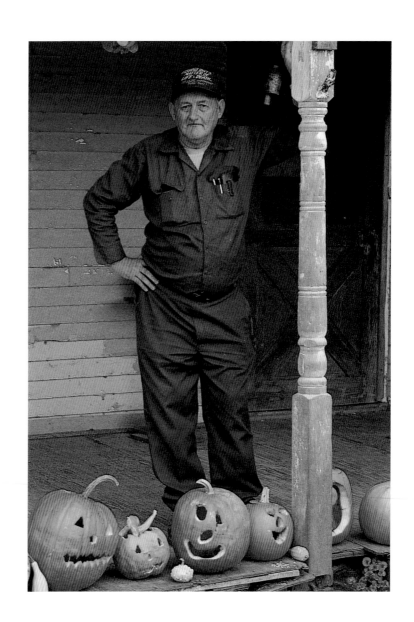

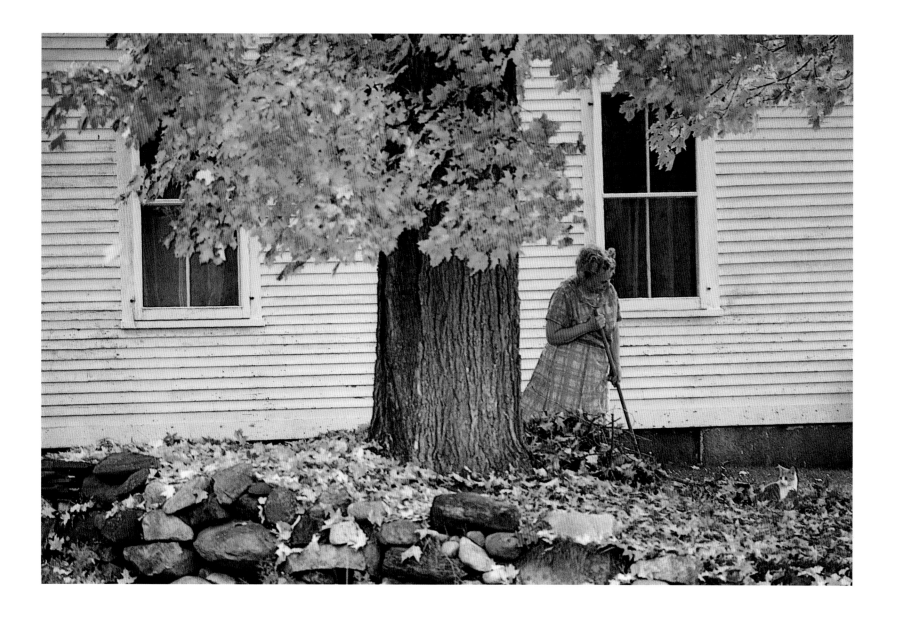

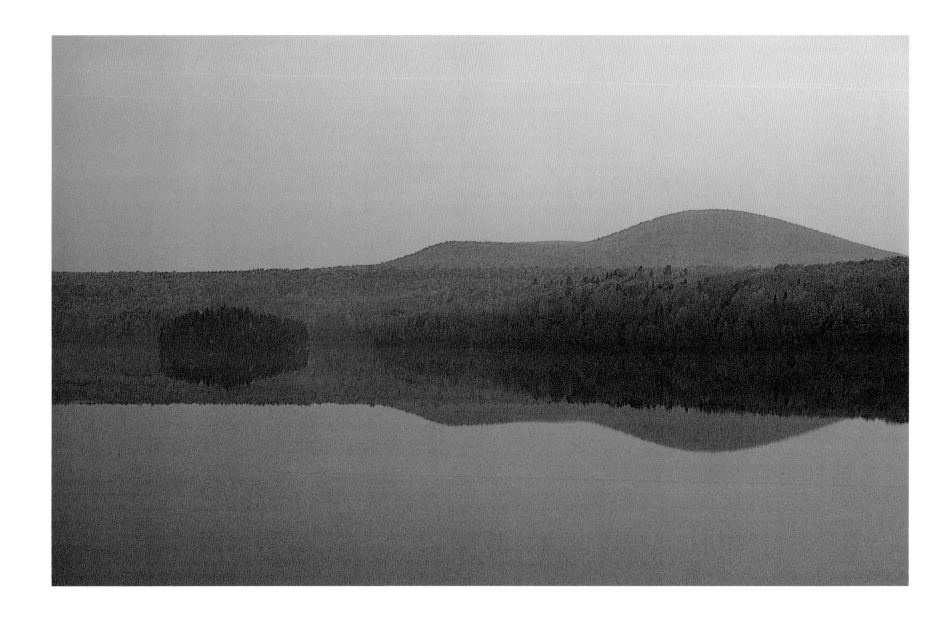

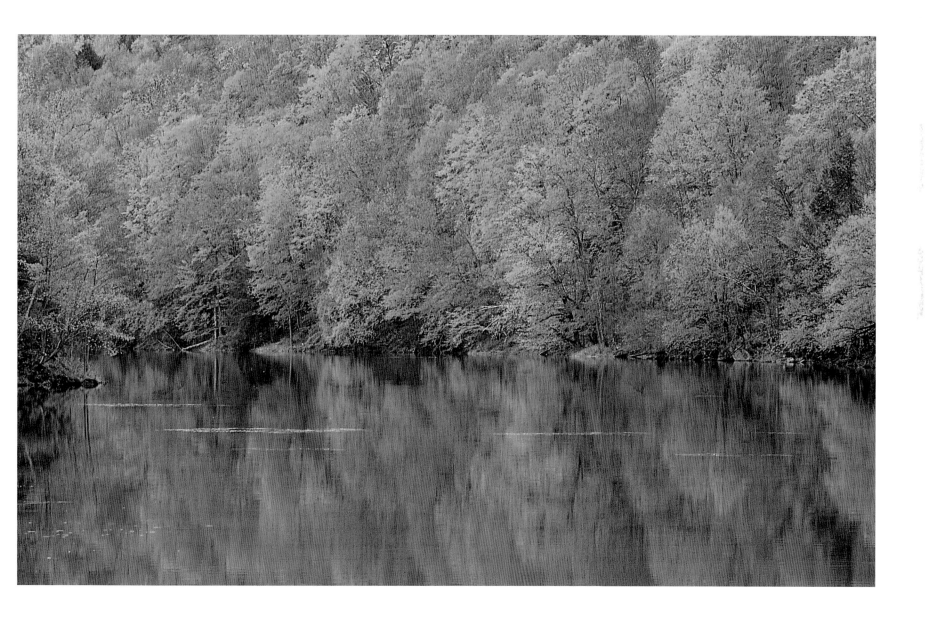

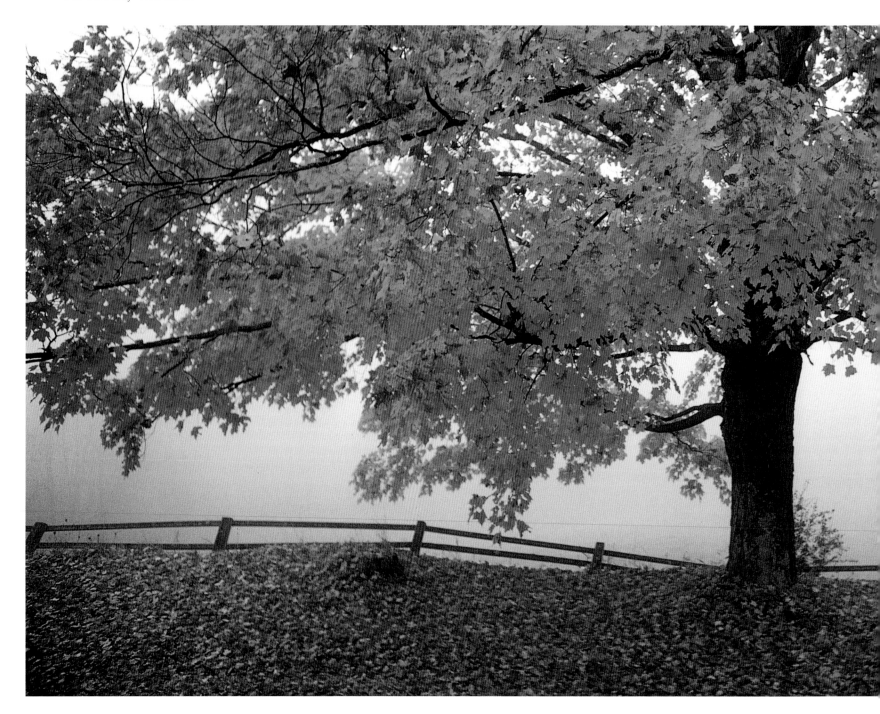

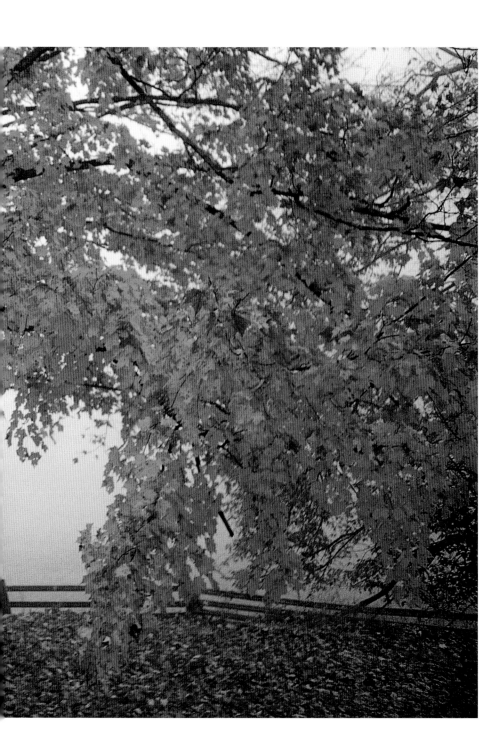

Sugar Maple

PLYMOUTH

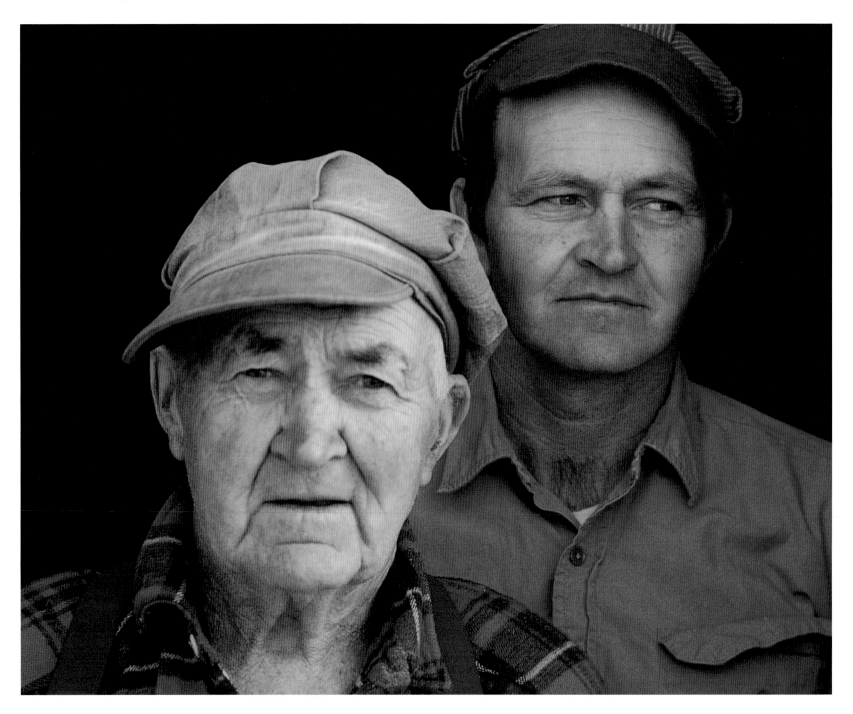

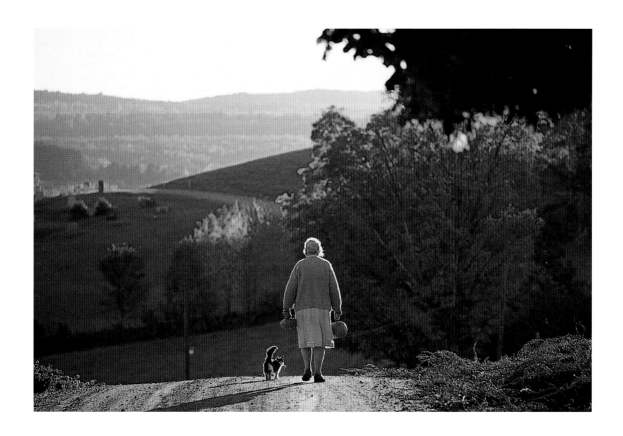

Opposite:
Father and Son

WEST BARNET

Left:
Gladys and Pumpkins

WEST BARNET

Overleaf:
Sunrise

PEACHAM

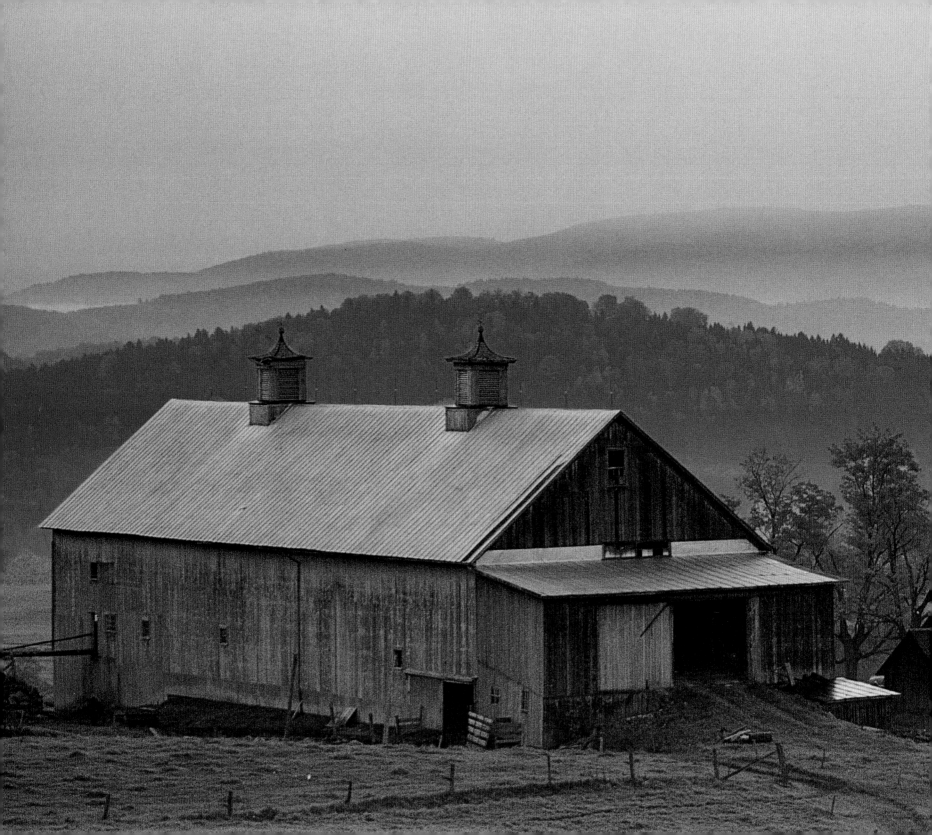

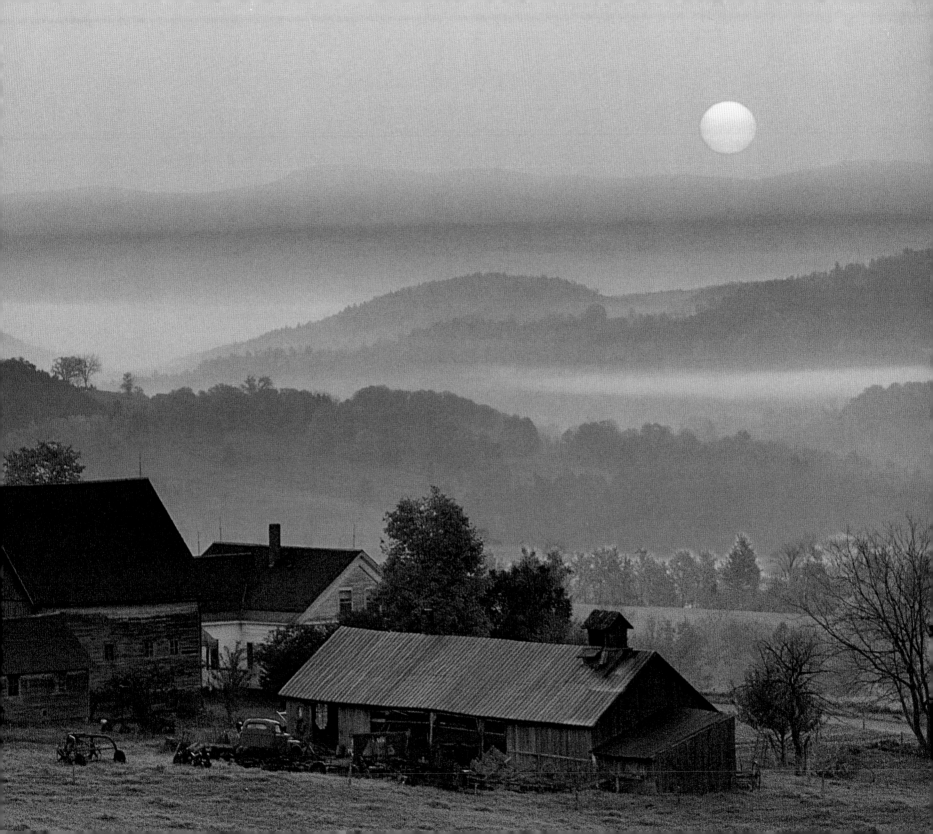

ACKNOWLEDGMENTS

THESE PHOTOGRAPHS WOULD NOT HAVE BEEN POSSIBLE WITHOUT THE generosity of all the Vermonters who welcomed me into their homes, and let me wander over their farms and woodlots to my heart's content.

I would also like to thank my editors, Kermit Hummel and Ann Kraybill, for their expert guidance; Fred Lee for his artful production; and John Barstow and Helen Whybrow for their help in launching this project.

Above all, I am deeply grateful to my wife Susan, this book's designer, for the elegance of these pages and her constant support and encouragement in bringing them into being.